ON DRAWING

SECOND EDITION

Roger Winter

COLLEGIATE PRESS

Collegiate Press
San Diego, California

Executive editor: Christopher Stanford
Senior editor: Steven Barta
Senior developmental editor: Jackie Estrada
Design and production: John Odam Design Associates
Photo researcher: Susan Holtz
Proofreader: Elaine Kleiss

Cover art: Käthe Kollwitz, *Self-Portrait, Drawing*, 1933, charcoal on brown laid Ingres paper, 18 3/4" × 25".
(National Gallery of Art)

Telephone: (619) 697-4182.

Library of Congress Catalog Card Number: 96-072189

ISBN: 0-939693-42-9

Printed in the United States of America

10 9 8 7 6 5 4 3 2

To my first artist/teacher role models:
Constance Forsyth,
Robert McDonald Graham, Jr.,
William Lester, Loren Mosely,
and Everett Spruce

Diane Burko
Community College
Philadelphia
Philadelphia PA

Fred C. Burton
Memphis College of Art
Memphis TN

Kenneth W. Bushnell
University of Hawaii at
Manoa
Honolulu HI

Nick A. Calcagno
Northeastern Oklahoma
A&M Tech
Northeast Miami OK

Harry Calkins
University of Alaska
Fairbanks AK

LeAnder Canady
Clinch Valley College
Wise VA

Cindia Carlson-Runyan
Southeast Community
College
Beatrice NE

Roseanne Cartledge
Prescott College
Prescott AZ

Robert Cartmell
State University of New
York
Albany NY

Frederick Cartwright
Saint Francis College
Fort Wayne IN

William Catling
Azusa Pacific University
Azusa CA

Curtis A. Chapman
Reinhardt College
Waleska GA

Richard Ciganko
Ohio State University
Lima OH

Nancee L. Clark
Santa Fe Community
College
Gainesville FL

Ross A. Coates
Washington State
University
Pullman WA

Steve Cole
Birmingham Southern
College
Birmingham AL

Kurt Coleman
University of Arkansas
Little Rock AR

Dee Connett
Friends University
Wichita KS

Gregory J. Constantine
Andrews University
Berrien Springs MI

Stephanie Copoulos-Selle
University of Wisconsin
Waukesha WI

Marty Cramer
Austin Community
College
Austin TX

Allen R. Craven
Lane College
Jackson TN

Larry Cressman
University of Michigan
Ann Arbor MI

R. Brinton Crocker
Purdue University
West Lafayette IN

Rodney Crossman
Indiana Wesleyan
University
Marion IN

Ward Davenny
Dickinson College
Carlisle PA

James A. Davies
Rockingham Community
College
Wentworth NC

Lynne Dees
Tarleton State University
Stephenville TX

Alba De Leon
Palo Alto College
San Antonio TX

Michel Demanche
University of Maryland
Princess Anne MD

William R. Detmers
Culver Stockton College
Canton MO

Robert deWitt
Utah Valley Community
College
South Orem UT

Joseph Di Bella
Mary Washington College
Fredericksburg VA

Paula Dickey
Alaska Pacific University
Anchorage AK

Eleanor Dickinson
California College of Arts
and Crafts
Oakland CA

Judith Dieruf
Frostburg State University
Frostburg MD

William S. Disbro
Jamestown Community
College
Jamestown NY

Phillip R. Dotson
Le Moyne-Owen College
Memphis TN

Kim Duboise
Pearl River Community
College
Poplarville MS

Kathleen M. Dugan
Anderson University
Anderson IN

Faye Earnest
Enterprise State Junior
College
Enterprise AL

Lynn Earnest
Southern West Virginia
Community College
Logan WV

Paul B. Edwards
Washington/Jefferson
College
Washington PA

Patricia Fallon
Ursuline College
Pepper Pike OH

Rusty J. Farrington
Iowa Central Community
College
Fort Dodge IA

Elen Feinberg
University of New Mexico
Albuquerque NM

Richard Finch
Illinois State University
Normal IL

Kimberly Finley-Stansbury
Southeastern Louisiana
University
Hammond LA

Allan Fisher
Dakota State University
Madison SD

Barnaby Fitzgerald
Southern Methodist
University
Dallas TX

Thad Flenniken
Garland County
Community College
Hot Springs AR

Eleanor Fox-Fay
Molloy College
Rockville Center NY

Arthur Frick
Wartburg College
Waverly IA

Milton Friedly
Elizabethtown College
Elizabethtown PA

James Fuller
Scripps College
Claremont CA

Lucy Gans
Lehigh University
Bethlehem PA

Robert Gerring
Mohave Community
College
Kingman AZ

Cara-Lin Getty
University of South
Carolina
Sumter SC

Benedict Gibson
Edinboro University
Edinboro PA

Cheryl Goldsleger
Piedmont College
Demorest GA

Drake Gomez
South Plains College
Levelland TX

Marilyn Gotlieb-Robert
Miami Dade Community
College
Miami FL

Sonia Grace
West Georgia College
Carrollton GA

Judith Greavu
Ohio Northern University
Ada OH

Mary Griep
Saint Olaf College
Northfield MN

Gerald J. Griffin
Ricks College
Rexburg ID

Charles A. Guerin
University of Wyoming
Laramie WY

Mirta Hamilton
Glendale Community
College
Glendale AZ

John A. Hancock
Barton College
Wilson NC

Keiko Hara
Whitman College
Walla Walla WA

David E. Harmon
Bethel College
Mishawaka IN

Joseph Hernandez D
Waubonsee Community
College
Sugar Grove IL

Susana Herrero
University of Puerto Rico
Rio Piedras PR

Steven L. Hicks
Oklahoma Baptist
University
Shawnee OK

Timothy High
University of Texas
Austin TX

Peggy S. Hinson
Methodist College
Fayetteville NC

William Hinton
Louisburg College
Louisburg NC

Michael Holloman
Seattle University
Seattle WA

Thomas Hovorka
Alverno College
Milwaukee WI

John Hrehov
Indiana University
Fort Wayne IN

Samuel C. Hudson
Rosary College
River Forest IL

Deborah Hurewitz
College of the Canyons
Valencia CA

Rosemarie Imhoff
State University of
New York
Oswego NY

Terry Inlow
Wilmington College
Wilmington OH

Harry Izenour
Kent State
Ashtabula OH

Ross Jahnke
Nicholls State University
Thibodaux LA

Goldena Jenkins
County College of Morris
Randolph NJ

Stanley Jenkins
Pembroke State University
Pembroke NC

Virginia Jenkins
University of Northern
Colorado
Greeley CO

Patricia Jenks
University of Maine
Augusta ME

Lynn M. Jermal
University of Wisconsin
River Falls WI

Jim Jipson
University of West Florida
Pensacola FL

George B. Johnson
Indiana University of
Pennsylvania
Indiana PA

Jayne Johnson
Queens College
Charlotte NC

Robert M. Jolly
University of Tennessee
Martin TN

Steven Jones
Lake Forest College
Lake Forest IL

David Kamm
Luther College
Decorah IA

Kent Kapplinger
North Dakota State
University
Fargo ND

Kathy Kauffman
Sierra Nevada College
Incline Village NV

Barbara A. Keen
Johnston Community
College
Smithfield NC

Candace Keller
Wayland Baptist
University
Plainview TX

Karen M. Kietzman
College of Saint Francis
Joliet IL

Evelyn Kiker
Mississippi Delta
Community College
Moorhead MS

Kent N. Kimmel
Salisbury State University
Salisbury MD

Wendy Kindred
University of Maine
Fort Kent ME

William Kitt
Valley City State
University
Valley City ND

Christine Koczwara
Tennessee Technological
University
Cookeville TN

Bill Komodore
Southern Methodist
University
Dallas TX

Barry A. Krammes
Biola University
La Mirada CA

Zed Krtic
Auburn University
Auburn AL

Anne M. Kwon
Teikyo Post University
Waterbury CT

Philip Laber
Northwest Missouri State
University
Maryville MO

Alice M. Lambert
Anna Maria College
Paxton MA

Stephen Lamia
Dowling College
Oakdale NY

Virgil D. Lampton
University of Tulsa
Tulsa OK

Roger S. Langdon
University of Memphis
Memphis TN

Ruth Lantinga
Kendall College of Art and
Design
North Grand Rapids MI

M. Le Compte
Sacramento City College
Sacramento CA

Billy Lee
University of North
Carolina
Greensboro NC

Howard Lieberman
Community College of
Allegheny County
Pittsburgh PA

Evan L. Lindquist
Arkansas State University
State University AR

Gregory Little
Kent State
North Canton OH

Katharine S. Little
Harcum Junior College
Bryn Mawr PA

Doris Litzer
Linn Benton Community
College
Albany OR

Valerie Livingston
Susquehanna University
Selinsgrove PA

Robert Llewellyn
Frostburg State University
Frostburg MD

Jonathan Lockard
Washtenaw Community
College
Ann Arbor MI

Jim Loomis
Lake Erie College
Painesville OH

Louis Lorenzen
Fitchburg State College
Fitchburg MA

Daniel G. Luongo
East Stroudsburg
University
East Stroudsburg PA

Thomas MacPherson
SUNY College
Geneseo NY

James Mai
Wenatchee Valley College
Wenatchee WA

Megan Marlatt
University of Virginia
Charlottesville VA

Don Marr
Hendrix College
Conway AR

Stephen W. Marsh
Daytona Beach
Community College
Daytona Beach FL

John Marshall
Meridian Community
College
North Meridian MS

Terry Martin
William Woods University
Fulton MO

W. Martin
University of Texas Pan
American University
Edinburg TX

Benjamin W. Marxhausen
Christ College
Irvine CA

Mary Ann Mason
Elizabeth City State
University
Elizabeth City NC

Bryan W. Massey
University of Central
Arkansas
Conway AR

Amy Matier
Community College of
Denver
Denver CO

George A. Mauersberger
Cleveland State University
Cleveland OH

Ernest Mauthe
Mercyhurst College
Erie PA

Ronald Mazellan
Indiana Wesleyan
University
Marion IN

Marilyn McCall
Suffolk Community
College
Riverhead NY

Lela McClanahan Carteret
Community College
Morehead City NC

Jacquelyn Mc Elroy-
Edward
University of North
Dakota
Grand Forks ND

H. McLain
Northern Arizona
University
Flagstaff AZ

Janet H. Mc Leod
Wallace College
Dothan AL

Gail Mead
New College University of
South Florida
Sarasota FL

Doug Melvin D
North Central Michigan
College
Petoskey MI

Clark Mester
Bowie State University
Bowie MD

Thomas J. Mew
Berry College
Mount Berry GA

Richard M. Mikkelson, Jr.
SUNY College
Plattsburgh NY

David P. Milby
Pennsylvania State
University
Abington PA

Lucy W. Millsaps
Millsaps College
Jackson MS

Irene Mitchel
East Stroudsburg
University
East Stroudsburg PA

Wayne A. Miyamoto
University of Hawaii
Hilo HI

Charlene Modena
Academy of Art College
San Francisco CA

Marge Moody
Winthrop College
Rock Hill SC

Kenneth Morgan
Bethany College
Bethany WV

John Morrell
Georgetown University
Washington DC

Betsy Jane Morris
Washington University
St. Louis MO

David C. Murray
Tyler Junior College
Tyler TX

Christopher Nadaskay
Southern Arkansas
University of Technology
Camden AR

Louise Napier
Wingate College
Wingate NC

Betty Nelsen
American River College
Sacramento CA

Gary Nemcosky
Appalachian State
University
Boone NC

Daniel Nie
Saint Andrews Presbyterian
College
Laurinburg NC

Amir Nour
Truman College
Chicago IL

David E. Pactor
Broward Community
College
Davie FL

Bob E. Palmer
University of Central
Oklahoma
Edmond OK

Marc Pandone
Solano Community
College
Suisun City CA

Dewayne Pass
Tulsa Junior College
Tulsa OK

Laura Pharis
Sweet Briar College
Sweet Briar VA

Mary E. Phillips
Phillips University
Enid OK

Howardena Pindell
State University of
New York
Stony Brook NY

Edwin Pinkston
Louisiana Tech University
Ruston LA

Carolyn Platt
Central Oregon
Community College
Bend OR

Barbara M. Poindexter
Longview Community
College
Lee's Summit MO

Rosemary Powelson
Lower Columbia College
Longview WA

Barbara Preskorn
Front Range Community
College
Westminster CO

Pamela J. Price
University of Texas
Odessa TX

James Prom
Rochester Community
College
East Rochester MN

Terry Puckett
Saint Philips College
San Antonio TX

Carl Purcell
Snow College
Ephraim UT

S. L. Rano
New Mexico State
University
Alamogordo NM

Barbara Rauf
Thomas More College
Covington KY

Ralph Raunft
Miami University
Oxford OH

John Rawlings
Flathead Valley
Community College
Kalispell MT

Brian A. Reeves
University of Wisconsin
Madison WI

Celeste L. Rehm
University of Colorado
Boulder CO

Alberto E. Rey
SUNY College
Fredonia NY

Vic V. Reynolds
Wayne State College
Wayne NE

Lonnie K. Rich
Lurleen B. Wallace State
Junior College
Andalusia AL

Rosalyn Richards
Bucknell University
Lewisburg PA

Robert R. Ring
Itawamba Community
College
Fulton MS

Marcia Roberts-Deutsch
University of Hawaii
Honolulu Community
College
Honolulu HI

Caroleigh Robinson
Meredith College
Raleigh NC

Ron Rodasti
Dakota Wesleyan
University
Mitchell SD

Conrad Ross
Auburn University
Auburn AL

Sandra E. Rowe
California State Poly
University
Pomona CA

K. Sabine
Rancho Santiago College
Orange CA

Kathy Sacks
Bethel College
McKenzie TN

Yvonne Sage
Brookhaven College
Farmers Branch TX

Caryl St. Ama
Glendale Community
College
Pasadena CA

Douglas Salveson
University of Findlay
Findlay OH

Eugene Schilling
Front Range Community
College
Fort Collins CO

Thomas Schlosser
College of Saint Mary
Omaha NE

James Schrosbree
Maharishi International
University
Fairfield IA

Melanie Schwartz
Southwestern Oregon
Community College
Coos Bay OR

Bette J. Sellars
Graceland College
Lamoni IA

Merrill Shatzman
Duke University
Durham NC

Charles Shoemaker
East Central College
Union MO

Walter Shroyer
Bluefield College
Bluefield VA

Deanna Sirlin
Atlanta College of Art
Atlanta GA

Arthur N. Skinner
Eckerd College
St. Petersburg FL

Bonnie Jo Sklarski
Indiana University at
Bloomington
Bloomington IN

Barry Skurkis
North Central College
Naperville IL

Ralph Slatton
East Tennessee State
University
Johnson City TN

Neill Slaughter
Long Island University
Southampton NY

Stephen Smigocki
Fairmont State College
Fairmont WV

Susan Smith-Hunter
Green Mountain College
Poultney VT

Kevin Sparks
Asbury College
Wilmore KY

Dorothy Spradley
Savannah College of Art
Savannah GA

Norine M. Spurling
State University of
New York
Buffalo NY

Charles E. Staats
Charleston Southern
University
Charleston SC

Steven Stancil
Snead State Junior College
Boaz AL

Alva W. Steffler
Wheaton College
Wheaton IL

James R. Stone
Hannibal La Grange
College
Hannibal MO

Signe M. Stuart
South Dakota State
University
Brookings SD

Kyra B. Sullivan
Broward Community
College
Pembroke Pines FL

Ronald Sullivan
Del Mar College
Corpus Christi TX

Sarah Sutro
Emerson College
Boston MA

Sarah Sweetwater
Northern Nevada
Community College
Elko NV

Barbara J. Swindell
Kennesaw State College
Marietta GA

Barbara Teague
University of Arkansas
Monticello AR

Ollie Theisen
Northeast Texas
Community College
Mount Pleasant TX

James Thompson
Willamette University
Salem OR

James P. Thompson
Azusa Pacific University
Azusa CA

Barbara Timm
De Pauw University
Greencastle IN

Lisa Tollefson
Jamestown College
Jamestown ND

Bonese Turner
Moorpark College
Moorpark CA

Helen Turner
Maple Woods Community
College
Kansas City MO

Anna Ursyn
University of Northern
Colorado
Street Greeley CO

Joy Von Wolffersdorff
State University
Northridge
Northridge CA

Randy Waln
Northern Montana College
Havre MT

Loyola Walter
College of Mount Saint
Joseph
Cincinnati OH

Bruce Walters
Teikyo Marycrest College
Davenport IA

Maxine Watter D
Marywood College
Scranton PA

Steve Watts
University of Charleston
Southeast Charleston WV

Gerald Westgerdes
Ohio University
Zanesville OH

Gary S. Wheeler
Miami University
Middletown OH

Carol White D
Cecil Community College
North East MD

Jon Whittington
Belhaven College
Jackson MS

Dawn J. Wilde
University of Colorado
Colorado Springs CO

Karen Willeto
Navajo Community
College
Tsaile AZ

Kathy Windrow
Eastfield College
Mesquite TX

Gregory Winterhalter
Southern Vermont College
Bennington VT

Debora Wood
Teikyo Marycrest College
Davenport IA

James L. Young
College of Eastern
Utah
Price UT

Deborah Zlotsky
University of Northern
Iowa
Cedar Falls IA

Contents

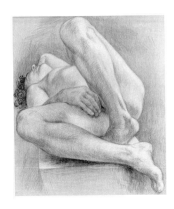

Preface

THE KEEPING, FEEDING, AND FANNING OF FLAMES IS NOBODY'S BUSINESS BUT THE GIFTED YOUTH'S AND HIS OR HER GOD'S. ANY HELP I GIVE BEYOND PATIENT WITNESS IS LIKELY TO BE MISCHIEF, WHATEVER THE LIGHT.

Reynolds Price

In this second edition of *On Drawing,* I have expanded the chapter on materials to include most of those that might typically be used in a beginning drawing class. I have expanded the chapters on line and value, composition, and play. I have added a section on linear perspective along with a discussion of alternative methods of depicting space. I have also added a chapter on common drawing subjects.

This edition may be less changed than I think, but I do know that being away from teaching for several years has given me a different vantage point than I had when I was up to my ears in the daily demands of the classroom and the frequent distractions of faculty politics. I have had the luxury of considering from a distance what a beginning student—and someone I may never meet—needs to learn and think about in order to have a solid foundation in drawing.

Drawing is not a static subject, not on any level. A text can only be seen as mere grist for the mill, and never as the beginning and end. There are many other resources: one's teachers, other students, the library, the collections of drawings in museums and elsewhere. This or any other drawing text can barely touch on all there is to learn.

The expertise and effort of many people went into the making of this book, and I am grateful for all the generous help I received. I especially wish to thank Max Winter for his editing and proofreading help on the

manuscript. I'd also like to thank the artists, museums, galleries, private collectors, and others who permitted me to reproduce the works used as illustrations, and to photo researcher Susan Holtz for helping track down many of the pieces. Thanks go also to the many students and ex-students whose work I have relied on so heavily as a source of illustration; the photographers for their valuable help; the people who appear in classroom photographs; those who critiqued my ideas; editor Jackie Estrada and the John Odam Design Studio for their help in producing a beautiful book; and all the others who were supportive and indulgent in so many ways.

R.W.

February 1997

1 Materials

Long ago, long before Grumbacher or even Winsor and Newton, artists prepared most of their own drawing materials. Michelangelo carved the bars of natural black and red chalks that he used in his studies for the Sistine Chapel ceiling. A youthful Dürer cast silver into the stylus he needed for drawing his exacting silverpoint self-portrait (Figure 1.1). Rembrandt quilled crow feathers into pens before giving them a new generation of flight in his marvelously free ink drawings (see Figure 2.6 on page 23).

Only a few contemporary artists bother to make their own materials now that they can buy anything they need at the ubiquitous art supply store and be back at work in a matter of minutes. Certainly technology has brought expedience, but it hasn't changed the expectations of our teachers and peers. We are still expected to connect with our materials, not only in a physical way but spiritually, too, making them extensions of ourselves. Like alchemists, we are expected to take inanimate substances (charcoal and paper, for instance) and breathe life into them.

Those artists of the past who prepared their own materials may have had a head start on us in terms of making

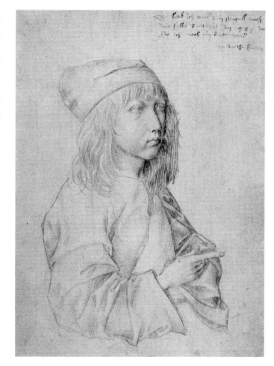

FIGURE 1.1
SELF-PORTRAIT AT THIRTEEN BY ALBRECHT DÜRER, 1484. SILVERPOINT. (ALBERTINA, VIENNA)

FIGURE 1.2

contact. Their leap from carving minerals into usable drawing sticks and then drawing with the same sticks seems not so quantum as ours, since most of our materials are fabricated by machines in some distant factory and then sealed in plastic before we get our hands on them.

It is at this point that our task as artists begins. We are to strip away the anonymity and sterility that has been built into the materials and, through use, make them our own. To speed up this unavoidable process, here are some tips for you as you begin your study of drawing in an antiseptic, prepackaged world.

MAKING CONTACT

Wear your worst clothes to drawing class so you won't care if they get dirty. Get your hands dirty every day (Figure 1.2). Get the floor dirty, too. Let it get cluttered with wadded up drawings and broken chalk. Work diligently at making your "first one thousand mistakes," to quote one of my own teachers. All artists have done this, and so must you. Throw yourself into your work as if your well-being depended on it. This is the rainy day you've been saving for. Make big ink splashes and spatters on a piece of paper. Don't worry if you miss the paper. Spill some ink, but never cry over it. Break long sticks of charcoal into shorter lengths to see which length works best.

Above all, don't misinterpret my suggestions as some

form of therapy. They are merely meant to help you overcome your natural human tendency to be afraid of those costly, bright, shiny new materials. The goal is for you to get to the point where you and your materials are no strangers to each other. Maybe you won't become friends right away, but at least you can get past the standoffish stage and be ready to begin working together "like the fortune teller with her cards."

PREVIEW OF MATERIALS AND TOOLS

Here is a look at the properties of many of the materials and tools you will encounter throughout this book and beyond.

Metalpoint

Perhaps the simplest version of a metalpoint drawing is made by scratching lines with the edge of a dime on a painted wall. The tradition of **metalpoint** (drawing with a metal stylus), whether using a point made of silver, gold, bronze, copper, lead, or some other metal, flourished during the Renaissance but fell out of favor in the wake of changing tastes and availability of new materials. Recently, drawing with metalpoints on prepared grounds has regained some of its popularity, perhaps because its slow, unforgiving nature seems an antidote to more expressionistic contemporary approaches (Figure 1.3).

Traditionally, metal styluses were used for drawing care-

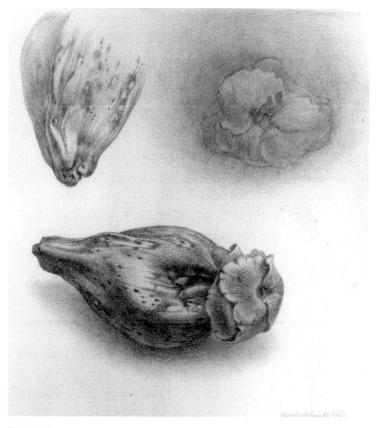

FIGURE 1.3
IMMATURE COCONUT BY
CHARLES SCHMIDT, 1992.
SILVER AND GOLD ON
PREPARED PAPER, 7" × 7".
(COURTESY OF GEROLD
WUNDERLICH GALLERY,
NEW YORK)

ful, small-scale studies of heads or figures. While many contemporary artists may still find this format and subject valid for them (see Figure 6.11, page 83), others have experimented with subject matter and scale.

A suitable rudimentary silver point, or other metal stylus, can be made with a slightly sharpened piece of the desired metal wire (too sharp will cut the surface) attached to a wooden dowel or used instead of lead in a mechanical pencil. A suitable ground (surface) can be made by painting paper with gesso or white watercolor paint applied in thin, smooth coats. Anyone with basic jewelry-making skills can cast a stylus in the metal of choice.

While metalpoint drawing is a medium for delicate work, it does not erase. It is basically a "put it down and leave it and try to do better next time" medium.

Pencil and Graphite Bars

The common "lead" pencil is a drawing material that everyone knows. It is not really lead, of course, but graphite. The popular general-purpose yellow pencil often gives way in a drawing class to a wide range of hard and soft drawing pencils from art stores. "H" is the hard range and "B" is the soft; 6H is harder than 3H, and 6B is softer than 3B. Other pencils, such as the flat ones that carpenters use, are certainly worth a try.

The pencil was originally called "lead" because it resembled leadpoint in its drawing qualities. However, a pencil is more versatile in the lines and tones it can make than is any metalpoint, and it can also be changed easily with a standard bar eraser. Pencils are popular tools for rough sketching, careful rendering, shading, and so forth. They are unparalleled for making pure, simple line drawings. The pencil is a lowly simple tool, but in an artist's hand it becomes a magical instrument (Figure 1.4), like a tin whistle played by a great flutist.

Graphite, in addition to being used for pencils, is also made into bars and sticks. In these forms, it can be applied to paper with the side, the edge, or the tip end. This approach is more appropriate for tones than a pencil is (Figure 1.5), but being made from the same material, all three tools have the same color and dull luster.

Chalk

"Chalk" encompasses a broad category of drawing materials. In the past, chalk referred to natural black, red, and white chalks mined from such mineral deposits as hematite, calcite, and shale and carved into usable bars of drawing material by the artists or their apprentices. Various fabricated chalks, especially pastels, have taken the place of natural chalks, although the minerals have not disappeared. If you find that you live near deposits of shale, or any other useful mineral, you may want to let your drawing class know about it.

Pastels are so readily available in such an array of colors

that it may seem excessive to make your own. But for experience and fun, I suppose, some artists do make their own pastel chalks by combining dry pigment with almost any binder, from gum arabic to soapy water, rolling the mixture into sticks and letting it dry slowly. The dust of pastels can also be moistened and shaped into sticks as a way of obtaining an odd assortment of colors.

The soft, fragile quality of chalks is the charm of the medium for some and the curse for others. Any artist who prefers a flat, linear look would not choose chalk for his or her medium. but in the hands of Edgar Degas (see Figure 6.6 on page 81), chalk was the perfect choice for a spontaneous approach to the play of light and color on figurative form.

Vine Charcoal

You know that lead pencils are not really lead and that chalk is usually a fabricated material. So you may be thinking that **vine charcoal** is also a misleading name. But at least some of the time, vine charcoal is really made from vines, and sometime from skinny hardwood sticks that have been bundled and tied with wire, enclosed in the chamber of a metal pipe, and burned to become charcoal. Vine charcoal is another fragile medium, like graphite, that is easy to erase. It may sometimes seem easier to erase than to keep down on the paper, because so much of its dust falls to the floor. If you accidentally drag your hand through

FIGURE 1.4
SEATED NUDE BY LOIS DODD, 1982. PENCIL, 10" × 13".

FIGURE 1.5
TORNADO BY BARRY GEALT, 1979. GRAPHITE ON PAPER, 23" × 30".

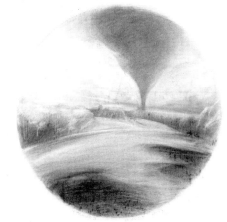

a worked area, you may find that you have rubbed most of the drawing away. Vine charcoal is often used in a quick, sketchy manner, but it can also be used for meticulous, careful work. Both qualities can be seen in Käthe Kollwitz's *Self-Portrait* (front cover). Soft or hard, fast or slow, vine charcoal is likely to become a standard medium in your drawing class.

Compressed Charcoal

A fabricated product, **compressed charcoal** is a condensed, extremely black material made from concentrated charcoal dust held together with a binder. It can achieve flat areas of black far more easily than vine charcoal or pencil can. Compressed charcoal is not a medium for the cautious, but it is often the favorite for those who want dramatic illustrations of weight and space, and for those who like to be energetically involved in the process (Figure 1.6).

Compressed charcoal is the material used in charcoal pencils. In this form, a small rod of the material is wrapped, or wound, with a strip of paper, and you peel the paper away as necessary to expose more charcoal.

Conté

Conté is a dry, hard material sold in small bar-shaped sticks. Its capacity for creating many tones makes it appropriate for light and dark studies; its atmospheric quality makes it ideal for drawing masses (see Chapter 5). Conté can be applied directly with the edge or end of the bar and left alone, or it can be spread around with the fingers and hands or smoothed into veils of tone with a chamois cloth. The combination of direct and indirect (rubbed and erased) applications of conté can be richer than either method used alone. A kneaded eraser is best for erasing conté. When your eraser begins to get dark from use, simply pull and shape it to reveal a clean area.

Scratchboard

Scratchboard is as much a method as it is a material. Unique in this book, a **scratchboard drawing** evolves from dark to light instead of the opposite. To prepare a ground for scratchboard, cover a good grade of illustration board or stiff paper with gesso or any other material that will remain smooth and not allow ink to penetrate its surface too deeply. Then coat the board with India or other black drawing ink (see the section on Inks that follows). When the ink is dry, you can use a stylus, such as an etching needle or some other needle or blade, to scratch through the ink coating, creating a white-on-black drawing.

The result often resembles wood engraving, but in the

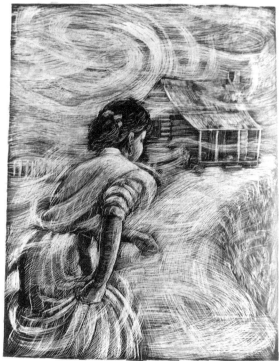

FIGURE 1.7
ILLUSTRATION BY BRIAN PINKNEY, 1990. SCRATCHBOARD. (REPRINTED WITH PERMISSION FROM *THE BALLAD OF BELLE DORCAS*. ALFRED A. KNOPF, NEW YORK)

hands of some artists, scratchboard takes on a fluid quality. The idea of scratching out the image is certainly not new, and scratchboard as a medium has been around for at least a hundred years. But it has recently been given new life by graphic artists such as Eric Drooker (see Figure 7.22, page 117) and Brian Pinkney (Figure 1.7).

Surfaces prepared especially for scratchboard are avail-

FIGURE 1.8
UNTITLED DRAWING BY
JACKSON POLLOCK, 1951.
SEPIA AND BLACK INKS ON
PAPER, 24 7/8" × 36 7/8".

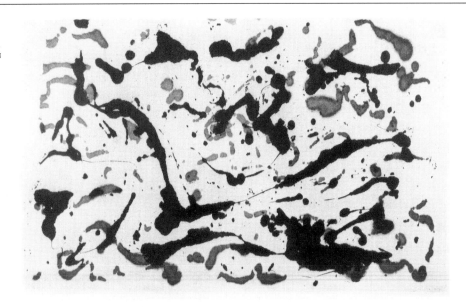

able in art supply stores and catalogs, especially those that sell graphic artists' supplies. You are likely to find using these clay-coated prepared boards more gratifying than working on a homemade surface.

Inks

Old Masters' inks, such as bistre (a brown ink made from wood soot), sepia (a fluid discharged by squid and cuttlefish), and black carbon inks, are all but out of use in our time. They have been replaced by liquid forms (rather than bars) of India ink, as well as various synthetically colored drawing and writing inks. Insoluble India ink, the most common, will satisfy the need for ink called for in this book.

The essence of ink is its fluidity (Figure 1.8). Trouble begins when you try to turn it into a dry material. It becomes stiff and tight, and a blob of ink turns into an unmanageable mess. The very moment you accept ink's flow, you have taken a giant step toward mastering a new medium.

To achieve a variety of tones in brushwork, you can thin the ink with water. Ink can also be left undiluted for powerful effects (Figure 1.9). Diluted oil paint and black watercolor can be used as substitutes for ink, especially in brush drawings.

Brushes

Literally *any* brush can be used with ink: bristles, sables, housepainters' brushes, mops, brooms, and so on. A common brush on the market is the bamboo brush, so called because its bristles are set in a short bamboo stick. Large sizes are probably best suited for newcomers to brush and ink drawing, because a large size won't permit the attempt at control that a small brush might. A large brush seems to encourage experimentation.

The way a brush holds and dispenses liquid gives it a spontaneous, fleeting quality not found in any other conventional tool. If the brush is filled with water and only the tip or a side of the brush is dipped in ink, the resulting stroke can contain a range of lights and darks. Through experimentation, you will get to know when, and in what amounts, to use water for thinning the ink so that your brush stroke will have the desired degree of darkness. A bold, confident brush stroke is a beautiful sight, while a hesitant, worried stroke is painful to see. For practice, just wet your brush and fill it with ink; hold it out at the end of its handle and move it across and around the page, welcoming the happy accident.

Pens

Reed pens, made from the barrels of bamboo, cane, or other heavy grasses, are ancient versions of the drawing pen. Though they are somewhat outdated, bamboo pens

FIGURE 1.9
STILL LIFE WITH PINEAPPLE
BY HENRI MATISSE, 1948.
BRUSH AND INK ON WHITE
PAPER, 41" × 28 1/8".

FIGURE 1.10
THE CATCH BY ALEXANDER CALDER, 1931. PEN AND INK, 22 3/4" × 30 3/4". (COLLECTION OF DR. AND MRS. ARTHUR E. KAHN)

and homemade reed pens are not that uncommon. The choppy marks of the reed pen certainly have their charm, but the strokes lack the potential flourish of pens made from the quills of geese, swans, and crows.

Metal pens—the pen type you are most likely to use—are fairly recent inventions, and any art store will have a wide variety of points, along with the staffs to hold them. You will want to buy a range of styles and sizes of metal

pens and, through trial and error, find the type best suited for any given approach.

Pen and ink is a medium of some flexibility in experienced hands, although it may not seem so at first. A pen can be used to make a pure and fine outline drawing (Figure 1.10), or it can be used to create tonal drawing by hatching and cross hatching, methods discussed in detail in Chapter 5. A pen is a familiar tool for writing, but like any

other approach to drawing, using a pen takes some practice and some looking at what others have done with it.

Ballpoints and Markers

As in fashion, drawing materials come and go. Bistre ink and quill pens are no longer the popular materials they once were, while the market is constantly adding new materials specifically intended for drawing, such as the art marker. Other materials—the ballpoint pen, for instance—are manufactured more for writing than for drawing. Nevertheless, ballpoints have worked their way into the drawing class, possibly unwelcomed by some instructors because of their mechanical line and lifeless surface quality.

Markers come in an exhausting range of colors and in several types. The spirit-based marker, because of its toxic fumes, is being replaced by alcohol- and water-based markers. The nib sizes of markers range from broad to extra fine.

Ballpoints have taken the place of pencils as the writing and drawing instrument most likely to be available (Figure 1.11). And it is their availability that makes them useful in a drawing class. A ballpoint is what you draw with when you forget to bring your other materials, when your budget won't allow you to buy other materials, or when you feel rebellious.

Paper

In a beginning drawing class, you will often be able to get by with a relatively inexpensive paper called newsprint.

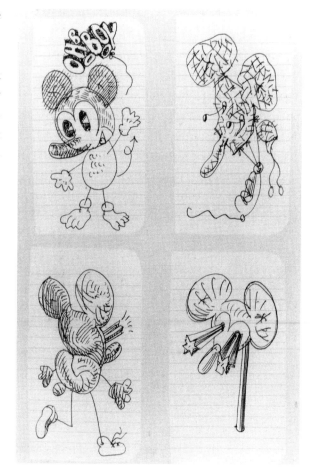

FIGURE 1.11
METAPHORIC STUDIES OF CARTOON MICE, "OHBBOOY" BY CLAES OLDENBURG, 1968. BALLPOINT PEN ON FOUR SPIRAL NOTEBOOK PAGES, EACH 5 1/8" × 2 3/4".

This low-priced, archivally unsound paper is sold in pads ranging in size from 9" × 12" to 24" × 36". Some enterprising people finagle the ends of rolls of newsprint free from newspaper offices and then cut the rolls into desired page sizes. The soft surface of newsprint will not take much erasing, and it will yellow in a matter of days when exposed to light. Newsprint is of greatest use in very quick drawings (see Chapter 2) or other rough exercises that you don't intend to save for posterity.

When buying paper, consider how you are planning to use it (see Table 1.1). Do you need a paper that will last? If so, it should be acid-free rag paper. As many of the better papers are sold in single sheets or rolls, what size will you need? Should it be smooth or rough? **Cold-press papers** are rough, and **hot-press papers** are smooth. A **plate finish** is the smoothest and is usually the finish of **bristol board**. Also, consider what you can afford—the price range for paper is staggering. Many manufacturers make an all-purpose pad that might serve your purpose in a beginning class. However, these papers should not be mistaken for

Table 1.1 Papers for Drawing					
SKETCH PAPER, PADS	PENCIL/GRAPHITE	CHARCOAL/CONTÉ/CHALKS	PEN AND INK/INK WASH	MIXED MEDIA	BALLPOINTS/MARKERS
Newsprint	●	●			
All-purpose	●	●	●	●	●
Watercolor paper, pads, single sheets, rolls (hot press, cold press)	●		●	●	●
Printmaking paper, single sheets, rolls		●			
Bristol, pads, single sheets (plate)	●		●	●	●

permanent quality; most often they are made from wood pulp and contain acid that will reduce their lasting power.

Papers are sold by weight (so many pounds per ream), and common sense will tell you how heavy or light, thick or thin, a paper must be for any given purpose. Sketchbooks, for instance, don't need to be made from heavy bristols, while a drawing on a large scale may need the structural strength and workability of a heavier paper.

Certain papers, such as charcoal paper or pastel paper, are designed especially for a particular medium. But this doesn't mean you can't try these papers with other drawing materials.

Additional Tools and Materials

Your drawing teacher may caution you not to overuse your erasers, because he or she may not want you to equivocate too much about leaving things down. But erasers are sometimes necessary. The kneaded eraser, art gum, and standard bar erasers (such as Pink Pearl or Magic Rub) are the types you will most often use in a drawing class.

A chamois cloth is useful for rubbing chalks, charcoal, and conté. As it darkens from the dust of materials, the chamois cloth becomes a form of drawing material in itself, especially helpful for starting drawings that are to become tonal drawings. This is the same material used for polishing cars, and it is least expensive when bought in that form.

Paper clamps and a masonite drawing board of adequate size are necessary when working on single sheets of paper.

Fixative is often used to protect the fragile surface of drawings. Be forewarned, though, that fixing a drawing is fraught with negative possibilities. For well-known environmental reasons, you should not use aerosol cans of fixative. Even if you can find a fixative in a less harmful atomizer form, you should still be sure that you are in a well-ventilated place and far from flames. Since spraying fixative directly at a drawing may blow away part of the drawing material or change its quality by wetting it (especially true of vine charcoal or pastel), you need to find a technique that minimizes damage. Some artists lay the drawing flat on the floor and let a mist of fixative fall on the drawing's surface from above.

Clay

In the art department where I taught, the sculpture teachers felt that working with clay from a model was an outmoded method of study. Therefore, it was never introduced into the sculpture classes. And yet I remembered how useful it had been for me as an undergraduate, how interested I became in looking for the planes that told me about the three-dimensionality of the head and figure. So I introduced clay into my drawing classes, not knowing—or caring— whether it was a form of drawing but knowing that it was *useful* to drawing since it brings vision and the sense of

FIGURE 1.12
COLOR PAPER STUDY OF
JAN VERMEER'S *YOUNG
WOMAN WITH A WATER
JUG*, FROM JOSEF ALBERS,
*THE INTERACTION OF
COLOR*.

touch into use as we circle around and around the model, viewing him or her from all angles. This experience is obviously not possible when drawing the model from one point of view.

The compositional aims of a clay study are quite different from the compositional aims of working on the two-dimensional space of a page, since clay has volume and weight. But clay does relate to drawing, since both are concerned with planes and proportions.

To work with clay you need no tools other than your hands, but you can make other tools with sticks, paddles, and wire loops.

Collage

Like clay, collage is not a typical drawing class medium. But collage has its uses, especially as a way of depicting the background spaces adjacent to an object or model (Figure 1.12). Also, cutting out shapes with scissors encourages an interest in line work (Figure 1.13). Matisse thought of cut paper as method combining drawing and color. But here, as always, I understand that each teacher has his or her priorities, and some may find the idea of collage not appropriate for a drawing class.

Found paper (magazines, wrapping paper, and so on) will be less coldly consistent than the colored papers sold in stores. In addition to paper, collage requires cardboard or some other stiff board for backing material, as well as scissors and glue.

Mixed Media

Using more than one material to make a drawing is a time-honored tradition (Figure 1.14). The combinations in mixed media drawings are endless, and anything is worth trying just to see the results. If you're not sure where to start, try combining charcoal with ink, or pencil with collage elements. Or, as a tour de force, see how many of your materials you can work into a single drawing.

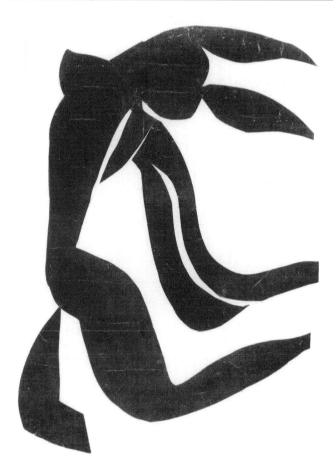

FIGURE 1.13
BLUE DANCER BY HENRI MATISSE, 1952. BLUE GOUACHE
DECOUPÉE WITH FAINT TRACES OF CHARCOAL, 42 1/2" ×
31". (COLLECTION OF THE BALTIMORE MUSEUM OF ART)

FIGURE 1.14
ABUNDANCE BY ALESSANDRO BOTTICELLI. BLACK CRAYON,
PEN, WATERCOLOR, WHITE LEAD HIGHLIGHTS, ON ROSE-
COLORED PREPARED PAPER, 31.7 × 25.3 CM. (COLLECTION
OF THE BRITISH MUSEUM, LONDON)

FIGURE 1.15
NIAGARA II BY
MICHELLE STUART,
1976. ROCK
INDENTATIONS, RED
QUEENSTON SHALE,
GRAPHITE, MUSLIN
MOUNTED RAG PAPER,
156" × 62".
(COLLECTION OF
WALKER ART CENTER,
MINNEAPOLIS)

Experimental Materials

With the exception of clay and collage, this chapter has dealt with traditional and standard drawing materials. This is, after all, a beginner's text. But even at the beginning, we need to think of drawing materials as open-ended. Recent drawing has been done with dirt, rope, light, and wire—in other words, with anything imaginable. For Figure 1.15, Michelle Stuart lists her media as "rock indentations, red Queenston shale, graphite, and muslin mounted rag paper." In a sense, Stuart has come full circle to the use of found materials as attributed to the Old Masters in the first paragraph of this chapter. But her reasons seem more directed toward breaking cultural habit than mere pragmatism. She is challenged by reaching beyond the predictable, and in turn challenges those of us who draw or who teach drawing. We need reminders that we are not simply keepers of a defunct faith but are also the proponents of the possibilities of expanding the medium.

Drawing has always made use of materials that are less permanent, therefore often less burdened with object-making responsibilities than oil paint or marble, for example. If your teacher suggests that you draw with sticks dipped in ink or by furrows cut in a sand beach, I can only say that he or she is teaching from the very finest drawing tradition.

SUMMARY

Making contact with your materials can be impeded by inhibitions about "getting dirty" and fear of wasting or damaging costly new products. You must feel free to become involved and familiar with your materials.

The materials and tools described in this chapter include metalpoint, pencil, graphite, chalk, charcoal, conté, scratchboard, ink, brushes, pens, ballpoints, markers, paper, clay, and collage.

EXERCISES

1. With each material, make marks using it quickly, slowly, boldly, and softly. Note the difference in the results.

2. Draw with a single material on various surfaces (papers and other materials), and compare the different effects.

3. Choose one of the mixed media drawings in this book (Figure 2.14 on page 27, for instance), and make a drawing using the same mixture.

GLOSSARY TERMS

bristol board

compressed charcoal

cold-press papers

conté

graphite

hot-press papers

metalpoint

pastels

plate finish

scratchboard drawing

vine charcoal

2 Gesture

A Chinese brushmaster criticized his student's drawing of an orchid because the drawing did not capture the "cloud-longing" of the orchid leaves. This quality the brushmaster referred to is the quality of **gesture**. Gesture is what the orchid leaves were doing.

LOOKING FOR VERBS

We see a potted plant reach toward the light. We see a mountain rise in the distance. We see the branches of a tree sway in the wind. We see a tired man slump in his seat. The quality of gesture in these events is the "reach," the "rise," the "sway," the "slump"—in other words, the **verb** that tells us what the object is doing. It is easy to sense the verbs, the gesture, in the examples I gave, but it calls for more imagination to understand that *all* things have gesture: a doorway, a tree stump, a pile of shoes, a calligraphic mark (Figure 2.1).

We are able to sense the gesture of an object, sense what the object is doing, through empathy. If we empathize with a tree, we become that tree for an instant, or at least we let

FIGURE 2.1
PROSE POEM ON FISHING
(SECTION OF HAND
SCROLL) BY CHU YUNG
MING, 1507. INK ON
GOLD-FLECKED PAPER,
12 7/8" × 26' 9 1/4".
(SIZE OF TOTAL SCROLL).

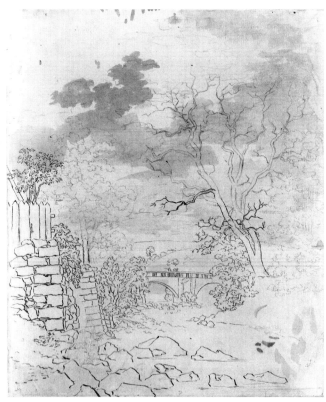

FIGURE 2.2
STREAM WITH BRIDGE BY
CASPAR DAVID FRIEDRICH, C.
1799. PENCIL WITH PEN,
PARTLY WASHED, 27 × 22 CM.
(COLLECTION OF
KUNSTHALLE, HAMBURG)

our bodies be like the tree in our imagination (Figure 2.2). And before we get to the nouns and adjectives that tell about the surface appearance of the tree, we respond to its verbs that tell about its essence.

Gesture is the life spirit of visual form. Can we think of any characteristic view of a person without first considering the gesture of that person? How a person looks at any given second depends on what she or he is doing. We who are artists call constantly on our abilities to intuit the gesture, the verb, because gesture gives life to our work.

THE ABSENCE OF GESTURE

The absence of gesture in a drawing is just as perceptible as its presence. No doubt you've seen drawings of landscapes in which the clouds seem to weigh a ton, or the stones look as light as marshmallows. You have seen portraits where the sitter just won't stay down in the chair. Unless these are intended qualities in the works, such as in surreal paintings, these are cases where the gesture is missing because the artist was not able to empathize with his or her subject.

GESTURE DRAWING

But theory, as Leonardo da Vinci has warned, must not be allowed to get ahead of performance. So with no further explanation, let me tell you how I would ask you to ap-

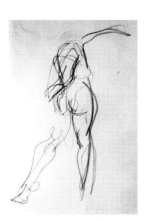

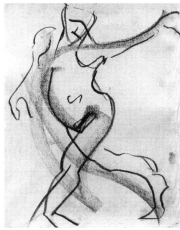

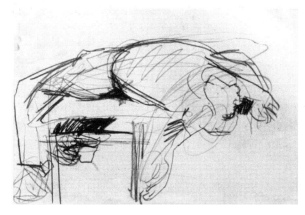

FIGURE 2.3
QUICK STUDY BY JOAN BLAKEMORE.

FIGURE 2.4
QUICK STUDY BY KATHY WINDROW.

FIGURE 2.5
QUICK STUDY BY DIANNE SCHLIES.

proach gesture drawing if you were a student in my introduction to drawing class.

First clamp 30 sheets of 12" × 18" newsprint to a drawing board placed on an easel. Stand, if possible, because standing while drawing lets you put "body English" into your work, and it allows you to step back for an overview of what you are doing. Ask your model to take an uninterrupted series of 30 one-minute poses. Be ready to draw using a dull, soft-leaded pencil. When the first pose is taken, start to move your pencil quickly around the page, following the lines of movement in the model's pose. Don't think. *React.* Make long circular movements that fill the page.

Don't scratch with the pencil. Leave it down on the paper and let it roam freely over the page like unwinding a ball of string. Move from top to bottom and from side to side and from head to foot and back again for the full time of the pose. Draw lines across the form and across the page and around the middle of the form. Gesture has no outlines, so avoid drawing them. Let the drawing breathe. Don't imprison it with hard boundaries. *Be excessive. Exaggerate. Distort.* Put energy in your work. Work overall (Figures 2.3, 2.4, and 2.5).

When the next pose is taken, start to draw immediately. To avoid losing time between poses, just rip the last draw-

ing from the clamps and let it fall to the floor.

Don't start the drawing at the top of the head and work down. Start with what you sense to be the most important aspect of the pose. Let's say the model bends down and reaches for an object on the floor. It is the bend and the reach and how these actions affect the entire form that is the true starting point of your study. The hair, the fingers, or other details are only important to the extent that they tell you about the bend and the reach. Everything is subservient to the gesture, the verbs. If you ignore this thought and indulge yourself in surface matters, you will be wasting time.

No matter how tired you get before the 30 poses are over, make an effort not to rest or to lose your concentration. Afterward, look over your group of drawings. Ask your teacher for a critique. Keep and date a few as a record of your progress. In subsequent sessions vary the length of poses from thirty seconds to three minutes. But a pose any longer than three minutes might sidetrack you into superficial concerns—skin, for instance. The first session of one-minute poses serves to bring order and rhythm in the context of a very challenging half hour.

INTUITION

It is possible, even likely, that you gave in to the urge to control the drawing you just made. A shaky outline around the model's head may be as far as you got with some of your drawings. It is not always easy to let go of a need to control. And it may not be control, in the long run, that you are being asked to abandon, but more likely your preconceptions of what drawing is supposed to be. I well remember learning about the discoveries to be gained through gesture drawing. It was my first year in art school and I *knew* I had found something of crucial importance: I had found an ability to draw intuitively. During my first vacation home, I tried to teach my father what *I* had learned. His looks let me know that he did not intend to cooperate. Since then, I've seen that look of doubt and fear and self-protection again and again on the faces of beginning drawing students, and just as often I've seen it melt away as the bigger truth of **intuition** is finally given a chance.

Rembrandt, whose work artists have turned to for various lessons over the past 300 years, was a master of gesture drawing. His fluid, spontaneous, free, expressive pen drawings sometimes come as a surprise to anyone familiar only with his paintings. It is a revelation to see Rembrandt's mastery of visual shorthand. His ink studies are the parent of his sustained works in painting, although the relationship may not be obvious on first viewing. His *Christ in the Storm on the Sea of Galilee* (Figure 2.6) is a good example of my earlier suggestion that before we indulge ourselves in the nouns and adjectives, we reach for the

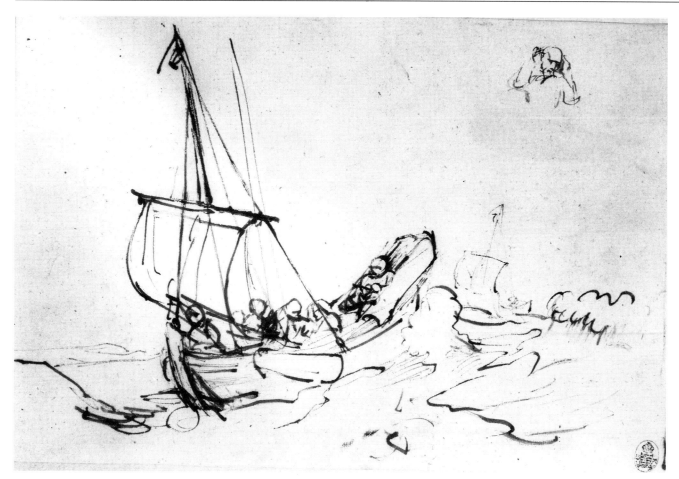

FIGURE 2.6
CHRIST IN THE STORM ON THE SEA OF GALILEE BY REMBRANDT VAN RIJN,
C. 1654–1655. PEN AND BISTRE, 7 3/4" × 11 3/4". (COLLECTION OF
KUPFERSTICH-KABINETT, DRESDEN)

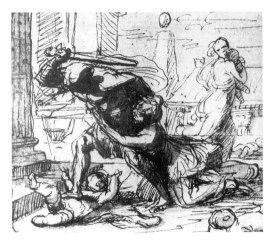

FIGURE 2.7
THE MASSACRE OF THE INNOCENTS BY
NICHOLAS POUSSIN, C. 1628–1629.
PEN AND BROWN INK WITH SOME
WASH, 5 3/4" × 6 5/8".

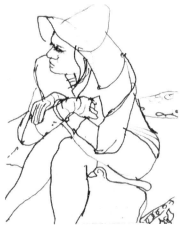

FIGURE 2.8
PEN AND INK DRAWING BY
RICHARD DIEBENKORN, 1963.
17" × 12 1/2".

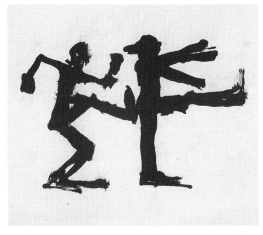

FIGURE 2.9
STUDY FOR THE KICK BY JUNE LEAF, 1976.
ACRYLIC ON PAPER, 7 1/2" × 9 1/2".
(COURTESY OF EDWARD THORP GALLERY,
NEW YORK)

verbs. Almost any detail in Rembrandt's drawing, with the possible exception of the heads, would be no more than abstract lines, totally nondescriptive, if viewed out of the context of the drawing. But in context, we feel—because Rembrandt felt—the churning power of the sea tossing the boat with its human figures. The "tossing" is the essence of the drawing.

This chapter contains several masterful studies for you to examine, including Poussin's *Massacre of the Innocents* (Figure 2.7). But this book will not show you all the drawing with gestural quality that you need to see. Ask your teacher for a list of artists whose drawings would be valuable for you to study at this point—artists whose work you can look up in the library. All masters are not Old Masters, and I hope you make yourself familiar with a wider range of drawings by such artists as Richard Diebenkorn (Figure 2.8), June Leaf (Figure 2.9), Isabel Bishop (see Figure 6.7, page 81), and Reginald Marsh (see Figure 7.27, page 120), to name a few of the twentieth-century master drawers represented in this book.

In your early phase of learning about gesture drawing, watch some experienced students draw through a series of one-minute poses from a model (Figure 2.10). Ask if they will watch *you* draw so that they can give you some pointers on improving your approach.

VARIATIONS

Let's imagine that you did not drop my class after the first 30 drawings and that I am still your teacher. Where do I take you from here? Well, at the beginning of the second class, I would insist that you move to a different place in the drawing studio than you stood in the first class. Some habits are good, like the habit of going to the library, but always going to the same spot in a drawing classroom is a habit that is likely to bring false security. My goal is for you to be able to draw well anyplace, anytime—not just in the northeast corner of Room 301. I would also suggest that you not draw with the same material every session. The dull soft pencil I recommended *is* a good tool for gesture drawings because it moves so easily over the page. But as you learned in Chapter 1, each tool has its own range of properties, and there is no better occasion than the demands of timed gesture drawing to learn about materials. You don't have the luxury of holding back.

Charcoal (both vine and compressed), various chalks, bars of conté, and bars of graphite all have a great potential for

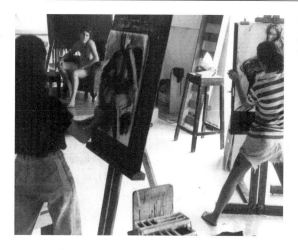

FIGURE 2.10
IF POSSIBLE, WATCH SOME EXPERIENCED STUDENTS DRAW.

tone, and tone suggests a third dimension. Gesture exists in three-dimensional space, so these tonal materials may help you study the space in which the gesture moves.

When you use compressed charcoal, rub it around with your chamois cloth. When the cloth itself gets black enough from absorbing dust from the charcoal, use it as a drawing material. Light areas can be drawn into these tonal drawings with your kneaded eraser.

If you have no natural enthusiasm for brush and ink, your teacher will probably nag you until you try it. The essence of ink is its fluidity, and a big bamboo brush uses ink's wetness and flow to the fullest. Your drawings with a brush are an inadvertently sensitive record of your boldness or hesitancy. Understand at the beginning that you

FIGURE 2.11
STUDY OF MOVING
POSE BY MARILU
GRUBEN.

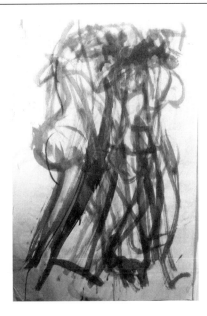

FIGURE 2.12
RUNNING NUDES BY
CHARLES CAJORI,
1962. CHARCOAL,
32" × 26".
(COLLECTION OF
SNITE MUSEUM OF
ART, UNIVERSITY
OF NOTRE DAME)

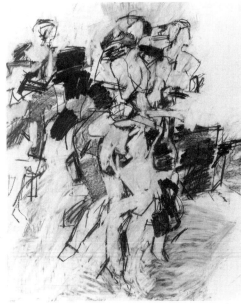

can't change the nature of this medium, so let it have its way. Be brave and positive. A bold approach with ink and brush produces wonderful results. A timid approach makes tortured drawings. Your natural taste may be for a delicate look, but *forte* comes before *piano*. If you are ever to achieve a softness that is resolute, you must first learn about being bold.

Using Models

Sometimes I, too, take quick poses for the class so that no one can complain too much when I ask for volunteers.

Each of us is a very different model, bringing nuances and new life to the human figure—bringing new verbs. Being a model also helps us understand what gesture really is, as we are responsible for supplying interesting poses for the class. Of course, a nude model, stripped of cuffs, collars, buttons, and so forth, is the ideal object for gesture drawings. But clothes have gesture, too, and it is never too soon for you to begin to see the inanimate objects in your world in terms of verbs rather than in terms of adjectives.

Most of the time, gesture drawings are of a static sub-

FIGURE 2.13
MUSCULAR DYNAMISM BY
UMBERTO BOCCIONI, 1913.
CHALK AND CHARCOAL,
34" × 23 1/4".
(COLLECTION OF THE
MUSEUM OF MODERN ART,
NEW YORK)

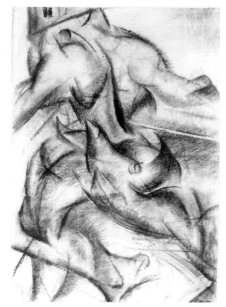

FIGURE 2.14
*DROPPED CUP OF COFFEE—STUDY
FOR "IMAGE OF THE BUDDHA
PREACHING"* (BY FRANK O'HARA) BY
CLAES OLDENBURG, 1967. PENCIL,
CRAYON, AND WATERCOLOR,
30 1/2" × 22 1/4". (COLLECTION OF
THE MUSEUM OF MODERN ART, NEW
YORK)

ject, usually the model in a quick pose. But drawing moving objects can be a challenging loosening-up exercise that relates, at least, to gesture drawing. I often include a **moving pose** in a series of gesture poses, sometimes at the beginning of the class, just to put you on your toes, not knowing what to expect next. A typical moving pose proceeds as follows: The model lets you know that he or she is going to move through three positions, just like doing an exercise over and over. The model holds each stage of the three-stage pose for a few seconds, with an occasional

gliding through the stages, for a period of three or four minutes. While the model moves, let your pencil or other material roam to where the model is at any given instance (Figure 2.11). Look at the model, not your drawing, following his or her movements across the page. You have to be free and willing or you won't even be able to get started. Don't try to "make a drawing." Just follow the model with your eyes and your arm. Look at Figures 2.12, 2.13, and 2.14 as examples of movement in the mature work of three artists.

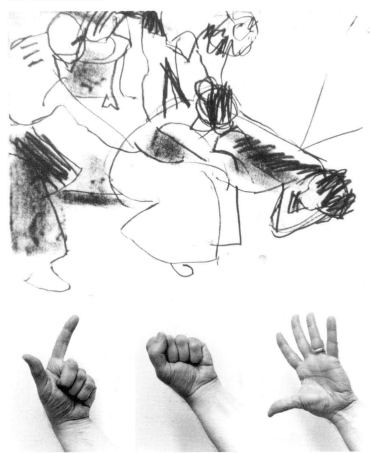

Group Poses

Another good variation of gesture drawing is the group pose (Figure 2.15). Two to four members of the class pose together while the rest of the class draw, taking turns on the model stand and at the easels, of course. The most important thing to remember with a group pose is to draw overall, seeing the group as a single unit. Look for the lines that tie the group together. Look for rhythm, movements, shapes. Do not draw one figure at a time. If you look for the overall, for unity, you may find that the experience of drawing a group is not so difficult as it may have sounded and that it helps you see relationships. Drawing groups of figures has the added benefit of forcing you out of the center of the page and into the peripheral areas.

It's easy to get into the bad habit of using the same kinds of lines for every gesture drawing, as the mind slips into a neutral state while the poses flash before your eyes. It's important that you overcome any passiveness and see each pose for what it is: unique. Look at the photographs of hands in Figure 2.16. A clenched fist is a very different gesture than a relaxed hand with fingers apart. Therefore, a gesture drawing of either of the two hands would call for a different approach if you are really empathizing with the subject. The clenched fist might be drawn with bold, determined lines; the relaxed hand with long, sinuous lines. This same idea applies to anything we draw, animate or inanimate, remembering that all objects have gesture.

SUMMARY

Spontaneity can be blocked by thinking that you must always be "in control." Often, newcomers to gesture drawing are given the authority to turn loose and take chances by watching experienced students at work and by looking at the spontaneous drawings of the masters, old and new.

Procedural approaches to gesture drawing differ depending on what material you are using. But regardless of the medium, gesture drawing always calls for a spontaneous, overall approach.

Once you have gained confidence with fast poses by a single model, you can vary the idea with moving poses and with group poses.

Finally, let me underline what you have no doubt discovered for yourself: Gesture drawing is not just some exercise in freedom, despite the tonic, loosening-up effect it may offer. Gesture drawing is a disciplined and penetrating form of study requiring constant alertness, total concentration, and great courage.

EXERCISES

1. Ask the model to take a 30-second pose. Don't draw during the pose. Instead, try to remember the pose through empathy. When the model breaks the pose, draw quickly what you remember. Repeat for five or six poses.

2. For a session of 30 minutes, make gesture drawings of objects in the room, of other people drawing, of different poses of your hand, and of faces.

3. Make gesture drawings from television.

4. Take a sketchbook and pencil or other easy-to-manage material to a public gathering. Make gesture drawings of the "found" models.

5. Make a series of gesture drawings with a string dipped in ink, remembering to avoid outlines.

GLOSSARY TERMS

gesture
intuition
moving pose
verb

3 Picturing Space

AESTHETICALLY, A TWO-DIMENSIONAL PICTURE OR DESIGN MAY BE ENTIRELY SUCCESSFUL, BUT THE DEVELOPMENT OF MOST SCHOOLS OF ART HAS LED TO A DEMAND FOR PERSPECTIVE OR A MEANS OF CREATING UPON A TWO-DIMENSIONAL SURFACE THE EFFECTS OF THREE DIMENSIONS.

Ralph Mayer

Self-taught artists tend to flatten images onto the surface plane (Figure 3.1), suggesting that the desire to make illusions of three dimensions is not so much an innate quality as it is an imitation of the ideals of historical art held up to us as examples by our culture. Making spatial illusions is often more intellectual than aesthetic, more perceptual than conceptual. And yet the desire to depict space has been with us since long before the science of perspective emerged during the early years of the Italian Renaissance. Egyptians suggested space by overlapping forms. Greeks and Romans used a perspective based on observation rather than rules. Japanese artists used **vertical perspective** by making objects that are farther from the viewer higher in the design.

Based on many years of watching people learn to draw, I think that most students of drawing would, through observation, learn to make adequate illusions of space without any knowledge of the rules of perspective. They would use their "common sense," as one of my ex-students said.

FIGURE 3.1
SELF-PORTRAIT BY HORACE PIPPIN, 1941. OIL ON CANVAS MOUNTED ON CARDBOARD, 14" × 11". (COLLECTION OF ALBRIGHT-KNOX ART GALLERY, BUFFALO, NEW YORK)

But to be ignorant of the rules seems almost as fraught with pitfalls as being a slave to them. With that thought in mind, I offer this brief look at the science of seeing.

ISOMETRIC DRAWING

In isometric drawing, each of an object's dimensions is shown in actual proportion, even though the object is tilted into space (Figure 3.2). This method of showing objects is diagrammatic rather than perceptual and is more likely to be seen in mechanical drawing, where a clear understanding of an object's measurements is more important, to say the least, than making believable illusions. In Asian painting of the past, the isometric approach was common (see Figure 3.16 on page 41).

LINEAR PERSPECTIVE

The aim of linear perspective from the visual artist's point of view is to create a realistic effect of deep space on a two-

FIGURE 3.3
SCHOOL OF ATHENS BY RAPHAEL SANTI, C. 1511. FRESCO. (THE VATICAN, ROME/ART RESOURCE)

dimensional plane (Figure 3.3). A scientist is more interested in understanding the mechanics of how the eye sees. The conflicting aims of artist and scientist may cause the science of seeing to seem imperfect to the artist. Linear perspective is based entirely on monocular vision, while most artists see the world with two eyes. But despite its flaws and shortcomings as a method of picturing space (other problems are discussed later in this chapter), linear perspective remains a basic teaching method in drawing classes that emphasize spatial illusion.

Following is a brief look at the vocabulary and mechanics of linear perspective.

FIGURE 3.2
ISOMETRIC DRAWING.

The Picture Plane

The **picture plane** is an imaginary plane between the observer and the observed. It corresponds to the surface plane of a painting or drawing and is represented by the rectangle in Figure 3.4.

The Horizon Line

A **horizon line** is a line drawn across the picture plane, sometimes beyond on either side, and it always corresponds with the eye level of the observer.

Vanishing Points

The underlying principle of linear perspective is that parallel lines seem to converge as they move away from the observer. A classic example is our view of a highway whose lines appear to join at the horizon (Figure 3.5). The point where they join is called the **vanishing point.** In *one-point perspective,* an object projected into space is sitting parallel to and therefore directly in front of the viewer's eyes. The frontal plane in the cube in Figure 3.4 that is parallel to the viewer stays unchanged. But the lines at the top of the plane, like the lines of a highway, appear to be getting closer together as they move away in space. If the lines of the top plane were extended, they, too, would appear to converge on the horizon line.

If the cube in Figure 3.4 is placed at an angle, or obliquely, in relation to the viewer, you can see that we now have two sets of converging parallels. Therefore, we need two

FIGURE 3.5
PARALLEL LINES MOVING AWAY FROM YOU APPEAR TO CONVERGE ON THE HORIZON.

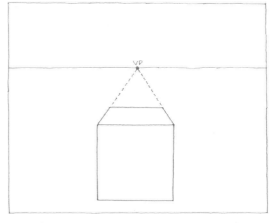

FIGURE 3.4
ONE-POINT PERSPECTIVE.

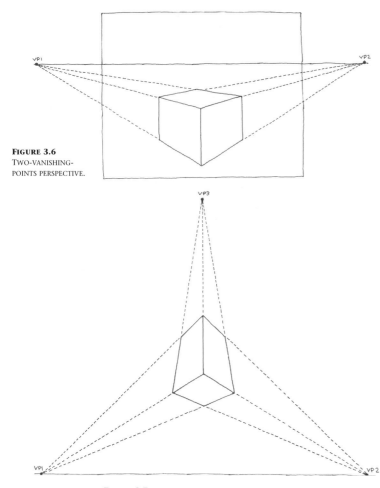

FIGURE 3.6
TWO-VANISHING-
POINTS PERSPECTIVE.

FIGURE 3.7
THREE-VANISHING-
POINT PERSPECTIVE.

vanishing points to make a drawing of the cube (Figure 3.6). Notice that none of the planes in *two-point perspective* are parallel to the observer. All visible planes appear to converge, and they all use the same two vanishing points.

Sometimes a third vanishing point is needed. If a form, such as a skyscraper, goes high above our eye level, we can use a third vanishing point to show the convergence of verticals (Figure 3.7).

Limitations of Linear Perspective

Linear perspective may be useful as an aid to seeing and in understanding the way we see. It is of greatest use when drawing architectural forms and of less use when drawing figures, landscapes, and other organic forms. Its rules, if followed explicitly, can seem somewhat ridiculous. Imagine, for instance, being on the 25th floor of a building looking out a window at a building 50 stories high. Vertical vanishing points would suggest that you see the building as a diamond shape defying common sense. Even more troubling for an artist would be the need to constantly set up diagrams with various points and lines before starting to draw. Linear perspective, for most contemporary realist artists, is used only as a general guide—a spatial checklist, as it were.

Aerial Perspective and Value

Aerial perspective means, in simplest terms, that objects farther away seem less focused and tend to lose their warm

colors as they are affected by the miles of blue atmosphere. In landscape drawing, aerial perspective is often shown by strong foreground details with the distance having less detail and closer values. Aerial perspective, in terms of its use in visual art, has no rules and is solely reliant on observation.

Artists refer to light and dark as **value.** Strong value contrast in drawing tends to give a solidity to objects and a sense of space to a room. Value is discussed more thoroughly later in this chapter and in subsequent chapters of the book. Value is the essential characteristic of chiaroscuro drawings, discussed in Chapter 5.

ALTERNATIVES TO RENAISSANCE PERSPECTIVE

Perspective, or the science of seeing, has been a central part of our legacy in regard to picturing space. Most of us are saturated with its vision because our culture has held it high, even if we don't know how to apply it to our own work. I have the impression that perspective's hold on us is so great that even major schools of art often pass over methods of picturing space that aren't related to optics.

Following are some alternatives to space making that have found their way into contemporary consciousness.

Outsider Art

Those creating **outsider art,** such as Howard Finster (Figure 3.8), are more interested in communicating a story or a subjective idea than imitating the way we see space. In this respect, Finster is closer to the emotional, expressive art of pre-Renaissance periods than he is to post-Renaissance art. The buildings in his work have an isometric feel to them, the most direct way to picture three-dimensional objects,

FIGURE 3.8
THE LORD WILL DELIVER HIS PEOPLE ACROSS JORDAN BY HOWARD FINSTER, C. 1980. ENAMEL ON MASONITE, 30 1/2" × 29 1/2". (HERBERT W. HEMPHILL, JR.)

FIGURE 3.9
IN THE PATIO BY GEORGIA O'KEEFE, 146. OIL ON PAPER,
MOUNTED ON PAPERBOARD, 29 3/4" × 23 3/4".
(COLLECTION OF SAN DIEGO MUSEUM OF ART)

but the scale of the figures and objects follows no set rules and seems to adhere to some personal sense of their importance. In other words, that which is important to the story is made large, while less important features are kept small. Apparently not content to let the picture carry the weight of the whole story, Finster writes directly into his work as he sees fit.

Abstract Art

In one sense, the space of outsider artists' work is related to an attitude toward space among twentieth-century abstract artists: in each, space relates to nature to the extent that it is helpful to the painter's ideas. Instead of serving nature, abstract artists, like outsider artists, are served by natural space in the sense that nature is a rough starting point (Figure 3.9).

"Primitive" Cultures

In any culture where making illusions of space is either not important, nonexistent, or considered inferior, decorative form becomes essential. Native North American sand painting and Mayan picture manuscripts have in common that the emphasis is on a precise use of line, on representation through two-dimensional shapes, and on pattern (Figures 3.10 and 3.11). The so-called primitive cultures of the world have contributed much, inadvertently, to modern and postmodern Western art. Their flattening-out approach to pictorial space is helpful in maintaining the picture plane,

FIGURE 3.10
SKY FATHER, EARTH MOTHER.
NAVAJO SAND PAINTING.

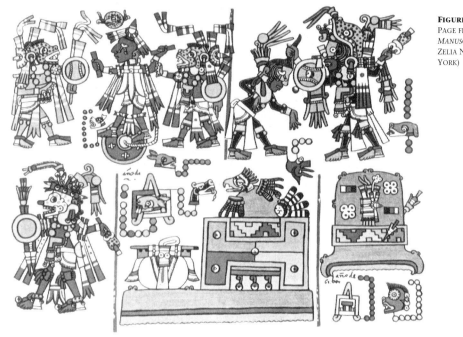

FIGURE 3.11
PAGE FROM *THE CODEX NUTTALL: A PICTURE MANUSCRIPT FROM ANCIENT MEXICO.* EDITED BY ZELIA NUTTALL. (DOVER PUBLICATIONS, NEW YORK)

a common goal for twentieth-century artists. Traditional Western painting used linear perspective to lead the viewer's eyes back into space, making the surface plane of the picture suggest a window. But as with a Native American design, we look *at* a contemporary painting, not *into* it (Figure 3.12). Both works confront us with two-dimensional space, as the forms in the works relate to each other on their surface planes.

Geometry

Cezanne was the Western painter who first violated conventional linear perspective (Figure 3.13), by tilting the spaces of a landscape, simplifying planes into geometric shapes, and including more than one point of view in a single work. Cezanne's ideas turned out to be only a few steps away from abstract art* and the intense drive of European artists to free painters and sculptors from the tradition of spatial illusionism.

Geometry, as it has done in so many times and places (Figure 3.14), provided a natural source for courageous visual thinkers of modern Europe intent on restricting the variables of painting to a few geometric forms interacting on a flat plane (Figure 3.15). No matter how extreme such

FIGURE 3.12
SELF-PORTRAIT WITH BLUE GUITAR BY DAVID HOCKNEY, 1977. OIL ON CANVAS, 60" × 72". (COLLECTION OF MUSEUM MODERNER KUNST STIFTUNG LUDWIG, WIEN, LEIHGABE SAMMLUNG LUDWIG AACHEN))

*Although the phrase *abstract art* is synonymous with modern art in popular usage, abstraction is a process that goes on at all times in illusionistic painting as the three dimensionality of nature is transformed to exist on the two-dimensional space of a canvas or page. *Nonobjective* is a more accurate description of art that attempts to abide by its own laws and take nothing from the surface appearance of nature.

FIGURE 3.13
MONT SAINTE-VICTOIRE SEEN FROM BELLEVUE BY PAUL CEZANNE, 1882–85.

works may seen to a person just beginning the study of art, he or she must understand the revolutionary change of attitude reflected by the underlying principles of the works before being able to completely understand current attitudes toward space.

FIGURE 3.15
STRUCTURAL CONSTELLATIONS BY JOSEF ALBERS, 1953–1958.

FIGURE 3.14
THE PYRAMIDS NEAR GIZA, EGYPT.

Perspective in Asian Cultures

Asian artists, before Eastern and Western concepts of picturing space were blurred by the effects of cultural interchange, had their own conventions of showing nearness and distance in art. Like Egyptian and Medieval artists, the Japanese, Chinese, and Indian artists suggested space by placing objects and levels of action one above the other so that distant objects were higher in the picture and often smaller. This is a logical approach to seeing but without the elaborate systems and rules of linear perspective, perhaps leaving the artists freer to concentrate on other pictorial ideas such as design, decorative color, symbolic content, and storytelling.

When oblique views of objects appear in Eastern painting, the presentation is often isometric (Figure 3.16). In an isometric view, the solidity of an object is made clear without paying any mind to the foreshortening of perspective. The directness of the isometric view is more compatible with a simplified outline style.

DRAWING FROM DIRECT OBSERVATION

Introducing these different concepts of depicting space—or ignoring space—may cause a new student of drawing to feel insecure about his or her world and the art of that world and where it is moving. But the challenge of new knowledge seems far preferable to the false security that reliance on a rigid system, whatever it may be, is apt to bring.

FIGURE 3.16
THE JEWELED CHAPLET FROM *THE TALE OF GENJI* BY CHOJIRO. HANGING SCROLL, COLOR ON PAPER, JAPAN, SEVENTEENTH CENTURY, MOMOYAMA PERIOD. (THE ASIA SOCIETY, NEW YORK)

Although the principles of linear perspective may help you understand what you see, these principles are no substitute for looking at what is in front of you. *Observation has no substitute.* If you can successfully get through the following exercises in simple drawings of simple objects, you can meet any other challenge in perception that lies ahead, because you will have learned all that seeing amounts to.

FIGURE 3.17
STAND AT AN EASEL AND STAY
AN ARM'S LENGTH AWAY
FROM YOUR DRAWING.

Before You Begin

If it is possible, stand at an easel when you draw. Give yourself plenty of backing-up room. Keep an arm's length away from your drawing at all times so that you will know the full size of your page and where you are placing things on the page (Figure 3.17). You cannot keep an objective attitude toward your work if your eyes are too close to it.

In Chapter 4 we will get to placement, positive-negative relationships, and other matters of composition. For now, just try to fill up your page with the object or objects you are drawing. Use the maximum amount of space without having to chop anything off.

Be sure to set up your easel so that you can see both the object you are drawing and the page you are working on without turning your head. All you should have to move are your eyes, looking back and forth from the page to the object and the space around it. *If you have to keep turning your head from object to page, you will lose too much information in the turns.*

Never fear making needed changes, but avoid erasing every mark you make.

Before beginning to draw, you will need to make some simple geometric solids with mat board. You can make cones with heavy paper. Coffee cans covered with white paper make adequate cylinders. Existing spheres, such as toy balls, are sufficient. Every form should be white so that lights and darks remain consistent.

Size and Angle Studies

Place a cube on a table so that you can see three of its planes. Clamp a sheet of 18" × 24" newsprint paper to a drawing board. Adjust the easel to accommodate your working height while standing. Use a medium-weight pencil (HB to 2B). Hold it by the eraser end—don't get a death grip on the sharpened end. Think about how you will fill the page with the single form of the cube. Try ghost drawing—moving your hand around the page without making any marks.

Draw one line, anywhere on the page, corresponding to a line of the cube. This line will be a ruler by which all measurements can be taken. You may discover a finer ruler as the drawing progresses, and you may be forced to abandon the size, angle, and placement of the original line. But for the moment, let the first line guide you.

Try to draw sizes and angles simultaneously. Try to make the largest cube that will fit on the page (Figure 3.18).

Here are some questions to ask yourself when measuring sizes and angles: Is this line shorter or longer than that line? Is this angle more or less than 90 degrees? Which of these two angles is the most acute? Of all the angles, which is the most obtuse? Keep checking angle against angle, size against size, keeping the drawing large on the page, until you are fairly satisfied that you have drawn the measurements as well as you can. Remember that you are measuring, not making pretty lines, and that the drawing is finished when the relationships are true and the cube fills the page.

You can do a similar line study of a pyramid (Figure 3.19). Use the same approach as in your study of the cube. When you see that a line or an angle in your drawing is obviously off, *take time* to make the necessary changes. A Pink Pearl eraser or equivalent is the best for pencil lines. Use it sparingly, but when necessary.

Sometimes errors in measurement get into your draw-

FIGURE 3.18
LINE DRAWING OF A CUBE BY MARILU GRUBEN.

FIGURE 3.19
LINE DRAWING OF A PYRAMID BY ED VICK.

ings no matter how much you have tried to keep them out, and their presence gives them an undeserved authority over you. With that in mind, keep your lines light and searching. Light lines are less committed, and they are easy to erase.

Don't shade or put in accidental surface details. If you work with a pure, simple line of consistent width, it will help you concentrate on getting relationships correct and keeping the pyramid large on the page.

When you think you have completed the pyramid study, make a setup using several simple solids, placed overlapping so that they partially conceal each other. Overlapping planes show you another way to represent the illusion of three-dimensional space on the two-dimensional plane of your page. Use the same approach to measurement in this drawing as you used on the previous two.

Value Studies

As mentioned earlier in this chapter, *value* is the visual artist's word for light and dark. A value study is the study of patterns of lights and darks seen in an object or group of objects and in the surrounding space. Value is so essential to drawing that I have given it special emphasis in Chapter 5. Value also figures strongly in the chapter on composition (Chapter 4). For now, we'll use value just to show that lights and darks, like lines and angles, can be measured.

For your first value study, make an arrangement of four or five simple solids with flat planes (Figure 3.20). Arrange the forms so that they overlap each other, as in the last line study. Shine a light onto one side of your arrangement, or make sure it's near a window, so that one source of light dominates all others. You should see only three or four major values: a lightest light, a darkest dark, and one or two middle values. Avoid looking for any nuances at this point. You will be constructing your drawing with simple, flat planes.

As with your previous studies, clamp a sheet of newsprint onto a drawing board adjusted on an easel to your drawing height. You can use soft conté crayons, compressed charcoal, or one of the chalks discussed in Chapter 1. You will also need a chamois cloth and a kneaded eraser.

To start your drawing, apply a fairly even tone over your page with the side of your crayon and then rub it around with a chamois cloth or with the side of your hand until you have a consistent middle value covering the entire surface of your paper. Perfect smoothness is not necessary, so don't spend too much time at this stage of the drawing. Making the page a middle value will help you think in terms of values and will also cause you to *touch* every square inch of the surface of the page. This touch experience, along with the added practice of manipulat-

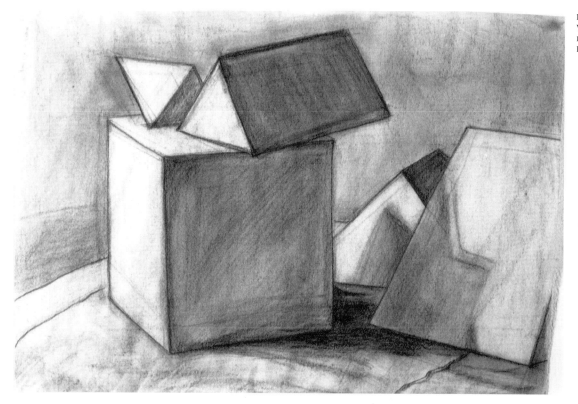

FIGURE 3.20
VALUE STUDY OF FLAT
PLANES BY MARGARET
BRINSON.

ing the material and the chamois, is a painless way to become involved with materials.

Next, do a somewhat hasty line drawing of the objects over the tone. Work as if you were making a very light version of your previous line drawings. Concentrate on size, angle measurement, and placement. You can do the line drawing with the end of your crayon. Once the lines are roughly established, start putting in the darkest planes and shadows with the side of the crayon and taking out the light planes with a kneaded eraser. Pull and knead the eraser before you start—this will make it a more usable tool. Don't feel that you must follow the lines of your original draw-

ing. Instead, check and recheck the proportions throughout the process of drawing. Ideally, you will be simultaneously establishing the overall distribution of values on the page and trying to assess the lightness or darkness of each value that you are observing.

Keep working until you are satisfied that you have found the correct value relationships, the correct measurement of angle and size, and a comfortable relationship between the size of the objects and the size of the page. In general, the larger you draw the objects, the better the relationship between objects and page. Give yourself plenty of time, but at the same time don't make a lifetime project of your first value drawing.

Curved Planes

You will now have enough experience to try a value study of a still life containing curved planes. Curved planes present a different challenge than flat planes because of their more subtle modulations of light. For instance, the darkest dark in the shadow of a cylinder is likely to be at the core of the shadow rather than at the shadow's edge as it might appear to be on a flat plane (Figure 3.21).

In your drawings based on flat planes you were asked to simplify the nuances of dark and light into a few areas of value so that your drawing would keep a clarity and a sense of purpose as a diagram of the phenomenon of light playing on objects. This holds true in your study of curved

planes as well. You are apt to notice the most subtle gradations of value caused by reflections picked up by the curves, but look only for the lights and darks that describe volume in space and leave out all those gradations that seem to you to be superficial.

The elliptical planes at the ends of cylinders present a common problem in drawing. In the ellipse diagrammed as a circle charted in perspective (Figure 3.22), you can see that the line of the ellipse is a continuous curve. Some newcomers to drawing tend to make points at the left and right sides of an ellipse. I have noticed that some advanced drawers still draw flowerpots and similar objects with foreshort-

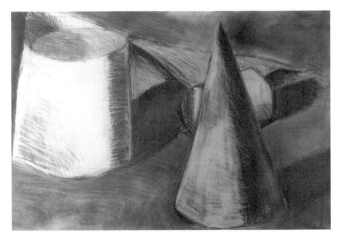

FIGURE 3.21
VALUE STUDY OF FLAT AND CURVED
PLANES BY JOAN BLAKEMORE.

ened circles (ellipses) like footballs pointed at the ends. For the sake of your drawing, take the time to study the nature of the curves.

Objects from Everyday Life

You can learn a great deal about volume in space by studying geometric solids. This understanding will serve you in far more complex drawings and will help you solidify your quick studies. But a steady diet of white abstract forms may start to bore you because of their limited challenge. To take what you have learned from them into more complex subject matter, you can set up a still life of familiar solid objects from everyday experience, such as kitchen utensils, musical instruments, tools, baskets—anything that would serve as symmetrical solids, as modulators of light, while offering a relief from the stark simplicity of geometry (Figure 3.23). Of course, other types of found objects will serve the purpose as well as the ones I've mentioned.

When making an arrangement of such objects, use the same manner of side lighting described earlier. Make your drawing using the same process as for the previous value studies, limiting yourself to a minimum of values. The complexity of your arrangement will determine the time you need.

This study is your first instance of needing to draw ob-

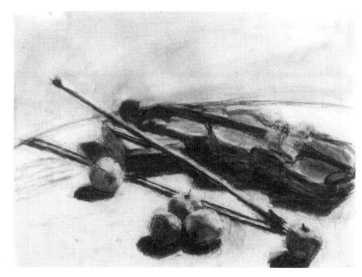

FIGURE 3.23
VALUE STUDY OF A STILL
LIFE BY JONAH WINTER.

FIGURE 3.22
THE RIGHT AND WRONG WAYS TO DRAW AN ELLIPSE IN PERSPECTIVE.

jects whose value differences may be caused as much by pigmentation as by light. Although you may not be able to avoid seeing the values occurring from the different colors, you should try to see what light is doing to the forms. It is , after all, through the play of light and dark on objects that you are able to see volume. Respond to the light and dark coming from the light source, and your drawing will be more solid.

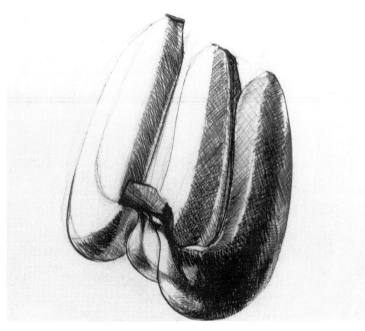

FIGURE 3.24
BANANAS BY ALFRED MARTINEZ, 1979. CHARCOAL PENCIL, 22" × 28".

Organic Forms

Organic forms such as vegetables and fruits provide an intermediate step between forms with symmetrical, "perfect" planes and the asymmetrical character of the posed model that you will be working with later. As familiar as an apple, a pear, or an eggplant may seem to you, you may discover that you never really looked at them before. Their basic structures and subtle surface planes may be a welcome relief from the machine-made objects you worked with in the previous arrangement, but they are not a ticket to forgetting to look, and look intensely, for measurements of sizes, angles, and values.

For a first drawing of fruits and vegetables, keep the arrangement simple—perhaps no more than three or four items (Figure 3.24). Once you get the "feel" of drawing the organic forms, you'll want to make a more complex second arrangement, emphasizing the contrasting shapes and lines. After your value studies have been taken as far as time and ability allow, I'm sure you can find culinary uses for the elements of your still life.

SUMMARY

This is the time in your study of drawing when you need to make a conscious effort to keep an open mind. As confusing as new ideas and new knowledge may seem, being eagerly open is your best chance to become comprehen-

sively informed. The chapter is not intended to be about systems of seeing versus each other or versus direct observation but how each may help you become a better artist or a more informed appreciator of art. No approach to drawing, including the ones described in this chapter, should stand unchallenged. Ideas about any aspect of art are to be considered, thought through, utilizing all the help you can get from your teachers and from your efforts at self-education.

ADDITIONAL EXERCISES

1. Lay tracing paper over Raphael's *School of Athens* (Figure 3.3) and extend lines to find where converging parallels meet. Try the same exercise with Hockney's *Self-Portrait with Blue Guitar* (Figure 3.12). What did you discover?

2. Chart a circle in perspective in five stages until it becomes a line.

3. As a class project, all students should draw an arrangement of fruit and vegetables. After the drawings are finished, vote on which drawing is the most successful. The drawer who received the most votes gets the fruit or vegetable of her or his choice.

4. Make a simple line drawing of a geometric solid on a very large page—perhaps four sheets of 18" × 24" paper taped together. Fill the page with that single object.

GLOSSARY TERMS
aerial perspective
horizon line
isometric drawing
linear perspective
outsider art
picture plane
value
vanishing point
vertical perspective

4 Composition

We start composing when we select a page of certain size and proportions. Awareness of the page is crucially important in keeping, throughout a drawing, the purity and strength of the **picture plane.** This chapter deals with retaining the surface plane while developing through composition the page's potential for deep space.

TWO-DIMENSIONAL SPACE

This duality of purpose can be understood by looking at Matisse's painting of his studio (Figure 4.1). Not only does the painting give a rare insight into the artist's arrangement of paintings and other objects against the planes of his studio walls and floor, but it also shows his arrangement of forms on the surface plane of the canvas. We

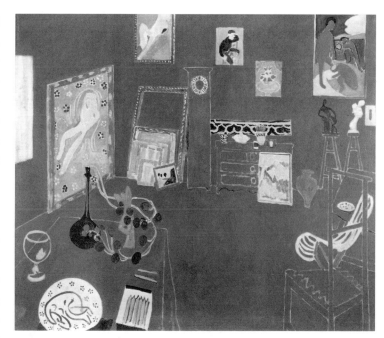

FIGURE 4.1
THE RED STUDIO BY HENRI MATISSE, 1911. OIL ON CANVAS, 71 1/4" × 86 1/4". (COLLECTION OF THE MUSEUM OF MODERN ART, NEW YORK)

can learn even more by observing the intervals between objects, the scale variation from large to small among intervals and objects, and the play of curves in an essentially rectilinear environment.

Negative Shapes

Just as a musician must work with silence and sound, the visual artist understands the use of open spaces, of **negative shape**, in a drawing. In the drawing you made of a cube, the space that the cube occupies is called the *positive shape,* and the area surrounding the cube is called the *negative shape.* If drawers are unaware of the negative shapes' important role in composition, then—barring a happy accident—their drawings will be seriously lacking. Tiny tight drawings swamped by expansive deserts of space on every side show no sense of positive and negative shape relationships. As a general rule, for now, make sure that the positive shape uses at least half the space of the page. This is a start, at least, of a comfortable relationship.

Placement

When I asked each member of a class to write a paragraph about drawing, one student wrote, "Drawing leads to an awareness of the physical world—a sensitivity to placement of things in one's surroundings. I constantly want to shift chairs, books, bottles to make a finer pattern where I live."

A choreographer works within the confines of the stage; similarly, a visual artist must place forms within a definite space: a canvas, a building site, a museum wall, an urban space. An architect works out his or her ideas on a site before getting deeply involved in further aspects of planning. A building's wall might resemble a canvas on which the forms of doors and windows are placed.

An interesting placement of a drawing of an object within the two-dimensional space of a page shows that the artist was aware of the perimeter of the surface plane, or the **frame of reference.** The frame of reference tells you where you are on the surface plane.

Shapes and Marks

Shape has become a popular forming device in recent paintings because its two-dimensionality lends itself so readily to retention of the picture plane. The use of pure shapes makes retention of the plane automatic. But even when shapes are only implied, as in the Matisse drawing in Figure 4.2, our attention is held on the picture plane because the interaction of areas bound by lines energizes two-dimensional space while deemphasizing deep space.

A repetitive mark or combination of marks can help retain the picture plane by calling attention to the overall surface. In Figure 4.3, the complexity of visual events on the surface attracts our eyes again and again, whether the events are dots, dashes, squiggles, cross-hatches, or any combination of these typical drawing devices.

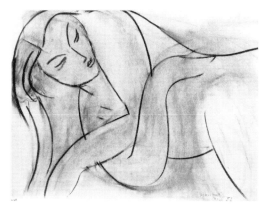

FIGURE 4.2
THEME AND VARIATION 1 BY HENRI MATISSE, 1941.
CHARCOAL, 15 3/4" × 20 1/2". (COLLECTION OF
THE MUSÉE DE PEINTURE ET DE SCULPTURE,
GRENOBLE)

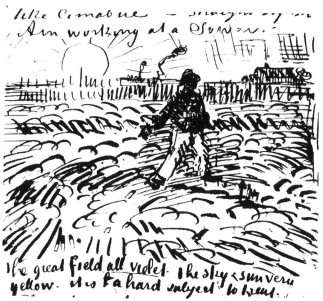

FIGURE 4.3
SKETCH FROM LETTER BY
VINCENT VAN GOGH. PEN AND
INK, 7" × 91/2". (COLLECTION OF
NATIONAL MUSEUM VINCENT
VAN GOGH, AMSTERDAM)

DEEP SPACE

Any illusion of depth on a two-dimensional plane is often referred to as **deep space**. Opening the possibility of deep space is like opening Pandora's box, as you can conjecture from our discussion of linear perspective in Chapter 3. You have already had valuable experience in dealing with deep space through your drawings of objects, but these drawings were essentially about the process of making illusions of space rather than composing within a spatial context. The following exercises attempt, like painless dentistry, to pull you gently into the potentially painful and complex experience of composing in deep space.

Compositional Studies

The great drawing teacher Kimon Nicolaedes stated unequivocally that students should make six compositional studies of great paintings each day for four years—almost 2,200 studies! The benefit of that much work would be enormous, but even if you make fewer compositional studies you will still profit through discoveries about the spatial relationships in successful two-dimensional works.

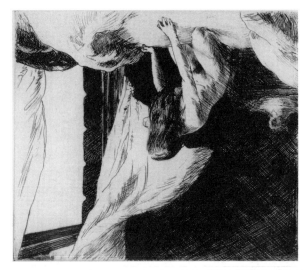

FIGURE 4.5
COMPOSITIONAL
STUDY OF EDWARD
HOPPER'S *EVENING
WIND* BY MARILU
GRUBEN.

FIGURE 4.4
STRUCTURAL RELATIONSHIPS ARE MADE MORE IMPORTANT
AND THE SUBJECT LESS IMPORTANT BY TURNING THE WORK
UPSIDE DOWN. *EVENING WIND* BY EDWARD HOPPER, 1921.
ETCHING, 6 7/8" × 8 1/4". (COLLECTION OF THE WHITNEY
MUSEUM OF AMERICAN ART, NEW YORK)

You might study all kinds of artworks, from paintings or prints you see in a museum or reproductions of works you've seen in your art history class. If you feel unable to make choices for yourself, ask your teachers for suggestions.

In my own classes I sometimes substitute compositional studies from slides for gesture drawings from a model.

Use simple materials for your compositional studies—nothing more than an ordinary soft lead pencil and some newsprint or other available inexpensive paper. Always start the study by making a rectangle that closely approximates the proportions of the picture plane of the work you are about to study. It's a good idea to first turn the work you are studying upside down to deemphasize the subject and instead emphasize the compositional relationships (Figures 4.4 and 4.5). You can complete the study by turning both the reproduction and your study in all four directions, making changes on your study with each turn. You may be surprised at the degree of objectivity this will give you.

As you make these studies, use long, sweeping lines (Figure 4.6). If you use value, try not to use it in spots. Look past surface details to the largest, broadest division of space you can see. Look for **rhythm**—repetitions of motifs—and **counterbalances** of shapes, lines, and values. Don't spend more than a few minutes working in any one direction. The entire

FIGURE 4.6
COMPOSITIONAL STUDY OF WINSLOW HOMER'S
BREEZING UP BY ROGER WINTER.

FIGURE 4.7
COMPOSITIONAL STUDY OF
MARY CASSATT'S *WOMAN IN
BLACK AT THE OPERA*
BY ROGER WINTER.

study may not take longer than ten or fifteen minutes—maybe even less. Taking more time on a study may only increase your interest in details, technique, and the descriptive aspects of the work you are studying, leading you away from the essential aim of the exercise: to work toward understanding the work's underlying spatial relationships.

Studies of Value Patterns

If you want to make studies of value patterns, you may wish to change to conté or charcoal, following the same process of turning the reproduction and your study in all four directions. You will now find not only linear divisions of space but also the largest masses of light and dark: the value pattern. To avoid confusion, try to limit yourself to three or four values (Figure 4.7). Work fast—no more than ten or fifteen minutes per study.

Remember that you need to be rough and free with these studies, as they are studies, not products. If you are too careful in your approach to using materials, you'll inadvertently keep yourself from learning and doing as much as would be possible. Recall the idea of *forte before piano*. A beginning artist must learn to be loud and strong before he or she can achieve more subtle qualities that communicate clearly. So strive for a roughness, a spontaneity, that keeps the materials and the structure of your study alive.

FIGURE 4.8
THE GOLDEN DAYS BY
BALTHUS, 1944–48. OIL ON
CANVAS, 58 1/4" × 78 3/8".
(THE HIRSHHORN MUSEUM
AND SCULPTURE GARDEN,
SMITHSONIAN INSTITUTION,
WASHINGTON, D.C. GIFT OF
THE JOSEPH H. HIRSHHORN
FOUNDATION)

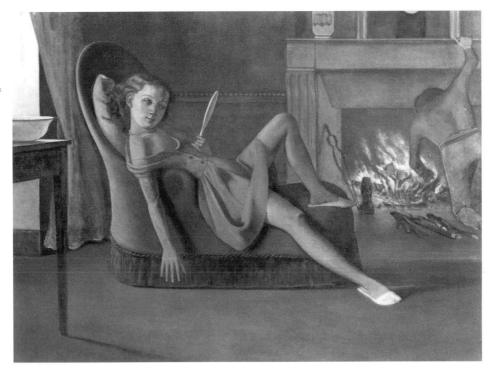

ANALYSIS OF BALTHUS'S *THE GOLDEN DAYS*

The quick compositional studies will give you extensive experience in learning to look at paintings and other two-dimensional visual works. Now I would like to take a closer look at a single composition, Balthus's *The Golden Days* (Figure 4.8) This study, although in depth, is still looking for the same rhythm, counteractive forces, linear division of the picture plane, and organization of values you tried to capture in your quick studies.

Visual works are not mental precompositions made according to a set of static rules. Even when a germ of a compositional idea is present, the actual work evolves by trial and error until a satisfactory solution is reached. In the case of *The Golden Days,* the artist may have had a rough

FIGURE 4.9
COMPOSITIONAL STUDIES OF BALTHUS'S *THE GOLDEN DAYS* BY ROGER WINTER.

mental vision of a pictorial idea before he began to draw or paint. Perhaps the idea started while he was drawing a certain model in a specific room. But then came the hard part of working out on canvas the linear construction, the light and dark and color, that contains the idea that carries forward Balthus's own voice, own vision in painting.

The painting has such clarity, such resolution and seeming simplicity, that we tend to take it for granted—to see it as inevitable. This is possibly a quality in all great painting, but young artists must try to understand that looking effortless is not being effortless. Looking effortless is simply a testament to the complete mastery of the artist.

Balthus's subject, in the hands of a lesser artist, could have been maudlin and stereotypical. But through Balthus's deep and enigmatic vision, he has infused it with a mystery and sensuality that make this painting like no other.

In terms of its linear composition—that is, its division of surface plane and deep space into interrelated areas—we first see a sweeping diagonal from upper left to lower right composed of the female figure, the chairback, and the curtain. This longest sweep is echoed by the girl's right arm, the line of the boy's torso, and the shadow of the table leg. It is counterbalanced by the axis of the girl's head, her left thigh, the mirror, and the boy's upraised arm (Figure 4.9). The profile of a basin, flames, and the ruffle of a curtain continue the curving organic forms of the figures into the interior space. The girl's spread fingers are a beautiful scale variation of the larger columns and the solids of the two figures. In addition to any symbolic meaning Balthus might have intended, the fingers repeat the

rhythmic flames, the fluted fireplace column, the sticks of wood on the hearth, and the pleats and folds of the girl's garment.

We see a similarly repeated motif in the dotted wainscoating on the wall (almost like a trajectory line), the girl's necklace, the buttons on the garment, and the braiding of the chaise longue. The turn of her head, the facial expression, the glance of the eyes, the boy's gesture—all are implied movements that become vital forces in the composition, although we may only sense them psychologically rather than regard them as abstract forms.

We are aware of two sources of light. A dim daylight outside the canvas on the left illuminates the wall, one side of the girl's body, her shoe, the back of the chair, and, to a lesser extent, the floor. These proportionately small areas of light combine with the firelight to play against a predominately dark and middle-value canvas. The darkest darks, like the lightest lights, are used to accent the middle-value composition and to provide scale and variation within an essentially middle-value work.

This is not the place to attempt to explain the content of the work, which in Balthus's case is always, it seems to me, on a preverbal level anyway. My discussion of visual components, such as scale, rhythm, contrast, counterbalance, and organization of values, is to give some inroads into how the work is put together: its "shape" as Ben Shahn might have put it. We are looking at the piece in the way a builder might look at a beautiful structure: to see how it is made.

MAKING YOUR OWN COMPOSITIONS

I have long been a skeptic of teachers giving too many projects for their students to do. No matter how well intentioned, assigning too many projects is, basically, thinking for the student. But in the area of composition, I have found that many newcomers need a jumpstart to get them acquainted with the malleability of the work processes required for using the imagination.

One Friday a long time ago, I assigned my painting class the following weekend project: make a drawing of four figures in the context of a landscape. Many people in the class were able composers when it came to working from models and still lifes, but not one had ever been asked to compose from the imagination before. The students were, to a person, baffled by my assignment. In the drawings they brought in, the figures were static, generic little triplets floating in a featureless landscape. I was quite surprised by the consistent ineptness of the drawings and, in desperation, did something I hadn't planned to. I pinned up a full sheet of heavy paper and started covering it with veils of chalk, much like the way I asked you to start your value studies. I thought of a sentence I'd heard years before, "Let the figures emerge from drawn space." This is not unlike watching figures walk

toward you out of a fog. And so I was creating the fog, the drawn space, with the veils of chalk from which the figures and the landscape would emerge (Figure 4.10a). I let the drawing remain uncommitted so that changes could be made easily.

At some point I began to divide the page with rough counteracting lines and contrasting values in a way that these areas of space *could* resemble a landscape (Figure 4.10b). Some of the shapes could even be seen as figures. At a point before the drawing evolved too far and became *my* drawing, I stopped. I turned the drawing upside down to further emphasize the plasticity of the process and the medium and asked each member of the class, one by one, to take turns working on the drawing. I kept reminding everyone of the subject, four figures in a landscape. The results were decisive, bold, and imaginative (Figure 4.10c). I pinned the original drawings next to the group study, and the contrast was in itself a valuable lesson. Members of the class concluded that not one of them had known how to start a composition from the imagination and that their drawings had betrayed an unwillingness to take a chance, any chance.

To wrap up, remember the idea of *forte before piano*. A bold approach is likely to work best, even if you don't know what you're doing. A timid approach, at this point, will get you nowhere. A timid approach will simply reinforce your inhibitions.

FIGURE 4.10
STUDIES SHOWING THE DEVELOPMENT OF A COMPOSITION FROM THE IMAGINATION.

(A)

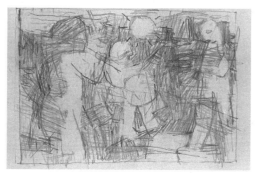

(B)

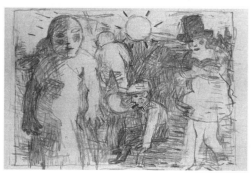

(C)

Sometimes we rush to details, forgetting that a composition starts with the broadest, simplest concerns, like dividing the page into its largest components of shapes, line forces, and values. Grandma Moses said she always started her works with a broom and ended with a straw. I believe that is a sound and workable principle.

You are given so many ideas to juggle that you may sometimes feel that you are dropping them, left and right. After all, how does the idea of gesture get together with the ideas of perspective and composition and the new thoughts you know are to come in subsequent chapters? I can only ask you to be patient with yourself, knowing that no one starts as an accomplished artist—not even Rembrandt. Only through much looking and working will you start to integrate all that you are learning.

SUMMARY

Open space interacts with any form or image drawn into the space. Modern Western artists have been interested in two-dimensional space and retention of the surface plane, or picture plane. They have experimented broadly with geometry as a means of bringing painting up to the surface plane.

Shape, repetitive marks, and placement reduce deep space by increasing interaction on the picture plane.

Exercises in composition can heighten awareness of the way a work is put together. In compositional studies, look for counterbalance, rhythm, contrast of movement, and organization of values.

ADDITIONAL EXERCISES

1. Draw an object (a potted plant, a head, a chair, etc.) by concentrating solely on drawing the negative shape.

2. Choose a painting, or ask your teacher to recommend one, and make an in-depth study of its composition, as I have done with *Golden Days*, drawing small studies of its various components.

3. Take one of your quick compositions and, turning it upside down, let it become the basis for your own idea and composition.

GLOSSARY TERMS

counterbalance
deep space
frame of reference
negative shape
picture plane
rhythm

5 Line and Value

THERE IS NO NEED TO
CREATE. TO CREATE,
TO IMPROVISE, ARE
WORDS THAT MEAN
NOTHING. GENIUS
ONLY COMES TO THOSE
WHO KNOW HOW TO
USE THEIR EYES AND
THEIR INTELLIGENCE.
A WOMAN, A
MOUNTAIN, OR A
HORSE ARE FORMED
ACCORDING TO THE
SAME PRINCIPLE.

Auguste Rodin

Line and value are the building blocks of drawing. Most people find they have a natural leaning toward one or the other, although anyone seeking real authority in drawing needs some proficiency in both line and value in order not to fall victim to natural prejudices.

LINE

We may think of lines in terms of stylistic treatment or as formal elements with intrinsic properties. Or lines can be simple outlines that divide one area from another, leaving positive and negative areas with equal strength (Figure 5.1). The following discussion of line qualities attempts to define line in these contexts.

Blind Contour

Blind contour drawing is a popular classroom exercise. It is often a revelation to the student, because the entire drawing is done without ever once looking at the paper. In blind contour drawing, you look only at the model or object you are drawing. This is considered a tactile exercise because you pretend that you are *touching* the edges of the subject's forms.

FIGURE 5.1
HENRI MATISSE DRAWING
WITH A BAMBOO POLE
TOPPED WITH CHARCOAL.

To start, clamp a sheet of paper to a drawing board. Get in a comfortable position and prepare to concentrate. With a fairly sharp pencil, touch the point to the page, pretending that you are touching some point on the contour—the edge—of the subject. It doesn't matter where you start. Begin to move the pencil along the model's contour, *never looking at the drawing. Look only at the subject.* Always come back to the sensation that you are touching the edges of the form. Move very, very slowly and patiently along the contours of the subject, missing nothing. Record even the slightest changes. For instance, if you are working with a live model, spend several minutes with the contour of the knee or the elbow. Go slowly. Remember that a contour is the edge of a three-dimensional form, not the boundary of a shape. Contour lines may move inside the form (Figure 5.2). Go slowly. Touch. Keep your eyes off the drawing.

Of course, blind contour drawing often leads to a disconnected and disproportionate study (you find this out at the end of the drawing when you finally get to look), but you will likely find that you never before have been able to see so much with such conviction as you have with this approach. And that is the second revelation of the blind contour approach.

The Dividing Line

As a young teacher, I discovered that blind contour drawing, despite its obvious benefits if approached honestly, is

FIGURE 5.2
FORSYTHIA BY ELLSWORTH KELLY, 1969. INK, 29" × 23".

somewhat of an end in itself. It does not allow the student to flow easily into the other uses of line. Its strength, the exclusive focus on the subject, is also its weakness—because sooner or later the demands of the page, as we saw in Chapter 4, are sure to surface. Placement, positive/negative relationships, spatial composition—these are matters that can't forever be left to chance. So I began to develop an exercise that uses to some degree the idea of contour and combines

it with certain page concerns. The line that I call for simply divides one area from another, leaving positive and negative areas with equal strength (Figure 5.3). A line quality to match this purpose is even, consistent, with no variation for style purposes.

In this exercise, positive and negative areas are of the same importance. If you consider only the positive shape, the line will imprison the shape rather than let it interrelate with its negative surroundings on an equal basis. If you consider only the negative shape, the positive shape will be lifeless.

Potted plants (Figure 5.4) are perfect for line studies. The presence of potted plants in the drawing studio gives the environment an interesting new dimension in terms of shape and line. Drawing a plotted plant is apt to be so painless that stopping drawing may be difficult (Figure 5.5).

For your first line study, clamp a sheet of newsprint or all-purpose paper to a drawing board. Use a medium to soft drawing pencil and a standard eraser. Choose a simple plant for your subject and place it on a table near your easel. *Very lightly,* draw in the desired placement of the plant's forms. Placing is an essential part of the ultimate drawing, so take as much time as you need. Be patient. Only when you feel that you have placed the object as well as you can should you start to draw the specific shapes and movements. Start at any point you wish. Go slowly. Give

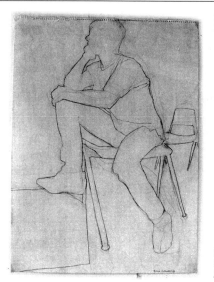

FIGURE 5.3
LINE DRAWING BY LAURIE HICKMAN COX.

FIGURE 5.5
LINE DRAWING OF A PLANT AND FIGURE BY JOAN BLAKEMORE.

FIGURE 5.4
PEPPEROMIA BY LARRY SCHOLDER, 1969. WOODCUT, 17 1/2" × 14".

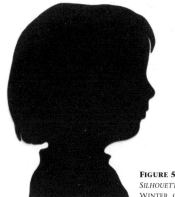

FIGURE 5.6
SILHOUETTE OF MAX BY JEANETTE
WINTER, C. 1978. CUT PAPER.

FIGURE 5.7
MEXICAN PAPER CUT.

each area of the drawing an equal amount of time. Take your time and enjoy the process of discovering the relationships of the shapes.

When drawing one side of a leaf (or one side of a plant), compare it with the opposite side. Look for rhythm, movement, and specific shape; they give energy to your draw-

ing. Don't generalize too much. Look for subtle details.

Consider the line weight in relation to the page. A heavy line might call too much attention to itself, obliterating the sense of shape. Each line should give the sense of dividing shape from shape—the line weight should suit this function.

A subsequent line drawing of a plant (or of a group of plants with contrasting foliage) might include a model, nude or clothed, in relation to the plants. Approach the model objectively, as you do the plants.

Another approach to the dividing line is to use scissors rather than pencil (Figure 5.6). In our culture, cutting silhouettes was once a popular craft and parlor game. In other cultures scissor cutting is an intricate form of decorative art (Figure 5.7). In any case, one can't miss the relationship between this unequivocal method and the precise, searching pencil line that I have described.

Beyond Outlines

The drawing by Alberto Giacometti in Figure 5.8 shows that lines can be used in a way that is at once descriptive and tonal. Giacometti's lines have other purposes than to define outlines—they seem to even avoid outlines. In addition to their being tonal, his lines are axial, compositional, and diagrammatic. They attempt to show relationships of forms in space. Using lines in this manner can be a helpful tool for you in learning to compose and deal with

straight and curved movements and the relationships of these movements. Outlines are so common in our approach to seeing that it may be helpful to force yourself *not* to use outlines in order to find, as Giacometti did, other uses and other meanings for line.

Line Variation

My students often joke about certain lines they called "art lines," meaning lines that vary from thick to thin or dark to light with facile textures and edges, all for the sake of a rather prematurely arrived at style. I never discouraged joking in this way, because it was funny and insightful and also put superficiality in its place. But such joking does overlook that line variation in masterful hands can be a joy to see.

Käthe Kollwitz's *Self-Portrait* (front cover) is indeed masterful in its variety of line quality through manipulation of the material—in this case, charcoal. The tonal work in the area of the head tapers off and becomes broad charcoal lines in the torso. The bold, black overlay of lines along the arm is like an expanding spring and is echoed in the piece of charcoal that the hand holds and along the profile, eye, and mouth. But the hand is drawn with great precision and knowledge of form and gesture, despite the quality of suggesting in the lines.

The line symbolizing the drawing board and paper would be, out of context, just a line. But we know perfectly well

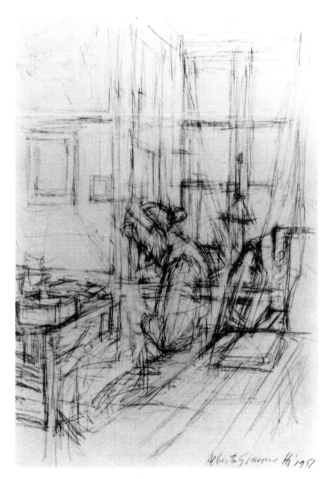

FIGURE 5.8
THE ARTIST'S MOTHER SEWING BY ALBERTO GIACOMETTI, 1951. PENCIL ON CREAM PAPER, 14 1/2" × 10 1/4". (COLLECTION OF WALTER KLEIN)

FIGURE 5.9
ILLUSTRATION FOR *THE WILD PARTY* BY ART SPIEGELMAN.

what it represents *in* context. The broad sketchy treatment
of the hair is clarified and brought forward by a few precise
lines following the movement of the head and describing
the ear.

The drawing seems to be a perfect balance of suggestion
and description and would suffer if either quality were there
in different proportion. Even with all its spontaneity, the
drawing seems inevitable. Its genius stands not only as a
testament to Kollwitz's talent but, more important, to her
mastery arrived at through years of discipline and hard work.

Hatching

While the upcoming section on value will concentrate on
light and dark, it is unavoidable that in some instances line
and value overlap. This is the case with **hatching** and **cross-
hatching**, methods of using line in closely spaced series
(Figure 5.9) or in series crossing over each other to achieve
varying degrees of light and dark in a drawing.

Hatching is most often done with pen and ink because
this approach is an obvious way for a pen to show grada-
tions of value. However, hatching can be done in any me-
dium, as can be seen in Figures 5.10 and 3.24 (page 48).

The principle of hatching is simple: hatched lines that are
closer together produce darker values, while those spaced
farther apart produce lighter values. Also, the widths of
hatched lines can be varied so that intense darks and deli-
cate lights can be achieved by changing pressures on the

FIGURE 5.10
COTTONWOODS BY BRIAN COBBLE, 1995. ETCHING, 7" × 14".

pen or by changing pen sizes. Hatching is a valuable method to learn not only because of its use in drawing but also as a method common in some printmaking techniques, notably etching and wood engraving. Your first efforts at hatching may be self-conscious and therefore turn out to be mechanical or stiff. But as with all approaches to drawing, practice brings confidence.

Materials

Lines may suggest using pencil or pen, but it's worth a try to make line drawings with chalk, brush and ink, charcoal, or any other material. It is through using different materials that we learn about our natural affinities, as well as what we don't particularly care for. And these discoveries are part of the process that helps us carve out a path to our own voices.

FIGURE 5.11
VALUE CHART.

I suggest making a line drawing while consciously avoiding outlines. You may also find that this is a good way to start a work intended to move into a mixed media approach.

VALUE

Value, as you learned in Chapter 3, can be measured. Often drawing and design teachers assign a value scale project that shows the range of values through gradations of light and dark bands (Figure 5.11). This is a helpful exercise because it allows you to see the degree of control you have over stating specific values.

As a follow-up project in measuring values, the instructor can cut up a black-and-white reproduction of a well-known painting into as many squares as there are students in the class or in a group. Each student's task will be to make an accurate value study of the square at a given dimension. Each study should be the same size, done with the same material on the same type of paper. The values in the study should exactly reproduce the values in the as-

FIGURE 5.12
CLASS PROJECT IN MEASURING VALUES. PENCIL
STUDY OF *THE CHILDREN* BY BALTHUS. EACH
SQUARE 4" × 4".

signed square. Students don't need to know what their square represents, since such knowledge might hinder their objectivity. When all students have finished their squares, the instructor can reconstruct the original painting by pinning up the squares in their relative places (Figure 5.12). Any square with values off will obviously look out of place

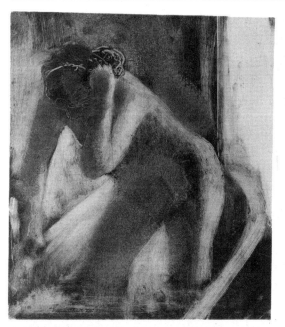

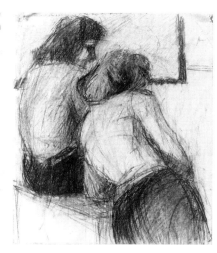

FIGURE 5.14
RUBRUMS BY SUSAN LEITES, 1982. COMPRESSED
CHARCOAL ON PAPER, 22 1/2" × 25 1/2".

FIGURE 5.15
DRAWING BY BRIAN COBBLE.

FIGURE 5.13
LA TOILETTE (LE BAIN) BY EDGAR DEGAS, 1880–85. MONOTYPE IN
BLACK INK ON PAPER, 12 3/8" × 11". (COLLECTION OF THE ART
INSTITUTE, CHICAGO)

in the reconstruction. These "off" squares should be re-drawn until the transitions throughout the reconstruction are smooth.

Mass

Value was presented to you as a way to draw simple objects in light and dark. Inevitably, as your drawing becomes more and more involved with positive-negative volumes of greater complexity than the subjects in Chapter 3, you will begin to use value not merely as shape but also as a way to show the third dimension. In other words, value will be a component of **mass.** Unlike shape, mass is three dimensional; it has volume, air, and light (Figures 5.13–5.15). Mass carves out deep space as well as moving from side to side and from front to back. In illusionistic terms, it

moves in and out of space. So now, as you proceed, you will have both value and line to depict three dimensionality as well as two-dimensional shape.

Pattern

Value plays a central role in showing solidity of form through light. Value is also often an important element in composing. If the darks and lights are simply and clearly organized, the composition will be solid. In contrast, if the distribution of values—the **pattern**—is spotty or agitated, the composition will be difficult to read.

Seurat's *Woman Reading* (Figure 5.16) is a fine example of a work with clearly organized values. Seurat has reduced the entire surface plan to a simple pattern of four or five values. Each square inch of this masterful work has been drawn with resolute simplicity and strength. The sensitive treatment of the edges of the forms counterbalances the strength of the overall pattern. In his perception of light, Seurat has, with the simplest of means, shown us that the light source is coming from our right to illuminate one side of the woman's face, hair, and shoulder. The only untouched area of the drawing is the white shape of light that is the page of the book. This light serves to illuminate the drawing and the mind of the reader in one elegant swoop. Seurat's mastery of his means enabled him to condense and compose from the natural work with seeming effortlessness.

FIGURE 5.16
WOMAN READING BY
GEORGES SEURAT,
C. 1885. CONTÉ
CRAYON, 12 1/2" × 9".

FIGURE 5.17
CRAYON DRAWING BY
BALTHUS, 27 1/2" ×
38 3/8". (COLLECTION OF
GALERIE CLAUDE
BERNARD, PARIS)

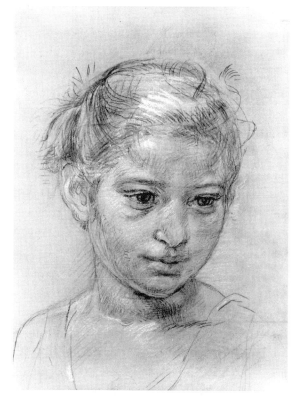

FIGURE 5.19
HEAD #5 BY ISABEL
BISHOP, C. 1938.
PENCIL, CRAYON, AND
CHALK, 11 3/8" ×
8 13/16".
(COLLECTION OF
WADSWORTH
ATHENEUM,
HARTFORD)

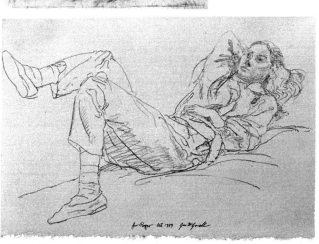

FIGURE 5.18
UNTITLED DRAWING BY JAMES MCGARRELL, 1989. SEPIA PENCIL, 10" × 15".
(COLLECTION OF ROGER WINTER)

Other examples of well-organized value patterns can be studied in Figures 5.17 and 5.18. Please don't presume that you can start where these artists left off. This work is offered simply as one more example from which to learn.

Chiaroscuro

If the toned ground drawings suggested in Chapter 3 were taken a few steps further, they would become what is traditionally known as **chiaroscuro** drawings (Figure 5.19). In a

classical chiaroscuro drawing, the paper is gray or a middle-value color. The darks in the drawing are applied with ink washes or chalk, and the lights are done with white paint or white chalk. The tone of the paper normally serves as background for the drawing as well as a middle value for the subject. The drawing is totally described through value. This approach to drawing can be refreshing as well as helpful because the lights are applied areas of chalk or paint rather than blank areas of paper. The lights, therefore, are given a more tangible and positive quality. A typical drawing on white paper with dark material obviously proceeds from light to dark. In chiaroscuro drawing, the process is somewhat reversed.

THE SUSTAINED STUDY IN LINE AND VALUE

Line and value, when combined, are both vital elements in the drawing process from the very start. To make a drawing with a line and then "fill in" with value, or to make values or masses and then draw lines around them, would be as inhibiting and mechanical as a coloring book. Values and lines, each a part of the original conception, must be used in counterpoint—to borrow a term from music—to create a harmonious whole. Don't forgo this principle. Understand it and use it from the start until you have mastered it. Only then can you have the authority to evolve beyond it.

The next few paragraphs will walk you through a sustained study in line and value (Figures 5.20 through 5.22). Assuming you are working from a life class model, ask the model to take a pose that he or she can hold for at least two hours with intermittent breaks. As soon as the pose is established, choose a piece of paper of a size, shape, and quality fitting the nature of the pose and the hard work it is about to receive. The paper will obviously need to be more substantial than newsprint. Choose a large enough size to allow you freedom of movement, and choose a shape that fits the composition that the pose suggests.

Start the drawing, as with your first value drawing, by putting a wash of conté, charcoal, or chalk over the page to suggest the weight of the figure and a sense of atmosphere in a room environment. Next, try to show the locations of the main forms of the figure and of the main lines of the environment. Give yourself ample time with this stage of the drawing, since placement is such a vital aspect of drawing. Keep the line light and free to ensure that subsequent changes can be made easily. Any hard, heavy lines at this point can make future changes almost impossible. Be noncommittal at this stage of the drawing. Let it breathe, just as you do in gesture drawings.

After you have established a general placement that satisfies you, and after you have worked out the general proportions, start to look for a simple value pattern, reinforc-

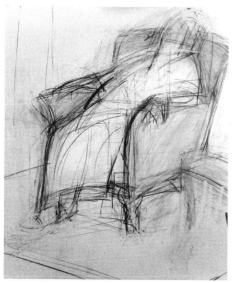

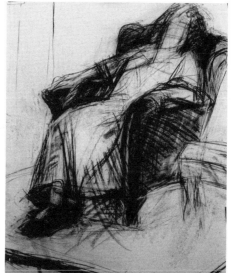

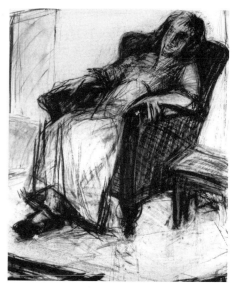

FIGURE 5.20
EARLY STAGE OF MASS AND LINE STUDY BY
MARY ELIZABETH HOWARD.

FIGURE 5.21
MIDDLE STAGE OF MASS AND LINE STUDY BY
MARY ELIZABETH HOWARD.

FIGURE 5.22
FINAL STAGE OF MASS AND LINE STUDY BY
MARY ELIZABETH HOWARD.

ing an edge now and then with a line, or using lines that are axial, compositional, or diagrammatic rather than outlines. Outlines are notoriously apt to bring errors into your work at this point, so *use them with caution.* Let values lead the way.

Feel free to use the material in as many ways as you can think of. Use its point as well as its edge. Apply it directly, rub it, erase it. A combination of approaches produces a rich sensation of space—richer than a single approach can

give. You can draw directly over rubbed or erased areas and then rub out the direct work and repeat the process. Lines as well as values can be "raw" or "worked." No part of the drawing should be considered final until this process is over. If you commit yourself too early, you will find that you are drawing in pieces trying to protect precious passages.

What are you looking for in the sustained study? You are looking for finer and finer abstract qualities, or qualities of form. Of course, for the drawing to have any authority as a

drawing from life, the proportions must be well observed and the volume in space must be strongly communicated. But the ultimate success or failure of the study depends on the strength of the structure, the interest of the value pattern, the sense of space, light, and air, and perceptual considerations. Perception and form must work together in balance, but formal considerations must lead the way. The drawing that discourages the artist is the one obsessed with details, always at the expense of the composition and general force of the total drawing. A student of drawing must learn to generalize, to move away from the specifics of materialistic nature to the broad, simple, general language of form.

The structural principle involved in making a drawing is equivalent to the formation of mineral crystals. As in the largest rock crystal, the largest, broadest aspect of drawing must belong to the same structural system as the smallest detail, despite any shifts and juggling of the form made during the process of the drawing. The drawing, while maintaining its general statement about the model and the environment, moves toward a complete structural study that integrates all of the components.

Surely all creative activities share the same process as a sustained study in line and value, the first phase being to get one's thoughts down in some form, regardless of appearance. Then it becomes a matter of going through the rough work, trying to find the ideas that are there or that must be fed into the work to keep it alive. The explicit choices, nuances, or inferences that come together in the ultimate work are too intimately bound up in subjective experience to translate into words—at least into words that, from the serious artist's point of view, do justice to the process and spontaneous discovery involved.

We often complete a sustained study with the haunting knowledge that, with the growth of our critical ability, we shall see much that should have been revised. Our hope is that something interesting will remain in the work. And often it does. I look back in amazement at some of my own early efforts, surprised that I still find something to be encouraged about, despite the sometimes hypercritical eye that years of teaching, looking, and working have given me.

SUMMARY

Lines and values as three-dimensional shape can be dealt with separately or combined in counterpoint. Pencils provide a pure line. Conté, chalk, charcoal, chamois, and kneaded eraser are the materials for value studies. Line-value combinations can utilize any or all of your materials.

Mass has volume, air, and light and moves in the negative volume of the page. In mass studies, the subject is drawn in two values: light and dark.

In sustained studies in value and line, both elements must be present from the first and carried through to the resolution of the work.

EXERCISES

1. Try using scissors to make quick studies with line. If you are working from a model, ask him or her to take a series of five-minute poses. Face the model with a piece of newsprint in one hand and a pair of scissors in the other, and cut out the shape of the pose. For variation, try scissor cuts of potted plants or other objects.

2. Clay studies are appropriate quick studies related to mass. The quality of three dimensions in the clay work forces an understanding of positive/negative volume relationships. You can do five-minute or thirty-minute studies.

For your five-minute studies you will need a fifteen- to twenty-pound bag of modeling clay and a strand of wire with short pieces of dowels attached to each end as handles. With the wire, cut off several pieces of clay, each about the size of a baseball. Ask the model to take a series of six or seven five-minute poses. The model must be seated or reclining, because standing poses require a means of support for the clay. With a piece of clay in your hand, start to move around the model, shaping the clay from every possible angle, looking for the model's gesture. Stay on the move; standing in one place too long would simply defeat the purpose of this exercise. Be alert, moving almost constantly, working the clay with your hands and making quick adjustments from every new view of the model. Keep your mind on the overall, the total pose. The appearance of the study is unimportant, since you will be tearing it down to make works of the next poses.

The thirty-minute approach is still a quick study, considering the medium. The process is somewhat the same as for the five-minute study, except that you will need a stand so that you can stabilize your slightly larger, somewhat more involved work. Also, you may want to use a sling tool (a small wooden stick with a wire loop at one or both ends) or even a stick or other homemade tool to flatten planes and cut recesses into the study. Keep your mind on gesture, pose, movement, and mass.

3. For a variation on materials, try drawing with a dirty chamois; then combine brush and ink with the chamois.

GLOSSARY TERMS

blind countour drawing
chiaroscuro
cross-hatching
hatching
mass
pattern

6 Subjects

THE GRAND, THE
HEROIC DRAFTSMEN . . .
HAD BETTER BE THE
MODELS [FOR ARTISTS],
THOUGH ONE'S AIM BE
FAR FROM HEROIC OR
GRAND. WITH THEIR
AUGUST HELP ONE
MIGHT LEARN TO LAY
ONE'S TRAPS AND
SPREAD ONE'S NETS, TO
SNARE THE SUBJECT
MATTER OF ONE'S OWN
INTUITION AND LIFE
EXPERIENCE, HOWEVER
SMALL AND SPECIAL.

Isabel Bishop

Surely there must be no category under the sun that has not been the subject for a drawing, sometime, somewhere. Any mechanical device, plant form, or piece of furniture can be seen as a potential subject for a drawing. My inclusion of this chapter is in no way meant to limit possibilities; rather, it is to point toward certain recurring subjects and say, "These are some of the things in our world that seem to have interested artists through the centuries. Look them over. Which do you feel an affinity with? What do you want to add?"

THE NUDE

In Western art, drawing the nude inevitably links to the figurative tradition in painting, drawing, and sculpture that was central to the art of the Greeks on up through the nineteenth century, and the tradition certainly continues on some fronts into contemporary times (Figure 6.1), even though the emphasis has changed. For instance, anatomy was a major concern of artists of the Renaissance because those artists wanted to use a scientific awakening of the

FIGURE 6.1
RECLINING NUDE BY PAUL CADMUS, 1993. CRAYONS ON WARM GRAY STRATHMORE PAPER, 19 5/8" × 17". (DC MOORE GALLERY, NEW YORK, NY)

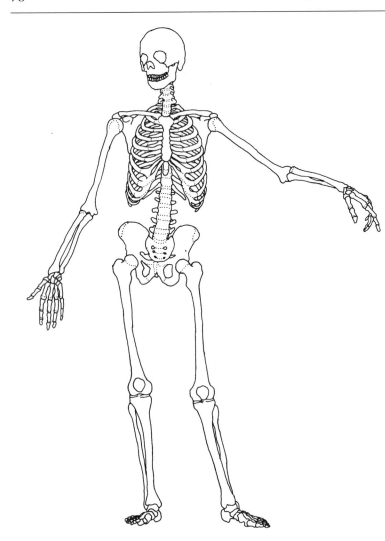

FIGURE 6.2
THE SKELETAL SYSTEM
(AFTER ALBINUS).

human body to paint and draw and sculpt the human fig-
ure in a lifelike way to display their skills and to dazzle
their audience. Concern with anatomy has waned over the
years as an art school subject. Nevertheless, some art teach-
ers and artists feel that s*ome* knowledge of human anatomy,
however rudimentary, is still essential to the study of life
drawing, and that life drawing is still a proving ground for
any young artist, even one wishing to move into expres-
sionistic or minimalistic approaches to art. With that idea
in mind, I humbly offer the following information and
thoughts about human anatomy.

The Skeletal System

A quick examination of the human skeleton (Figure 6.2)
shows that it is made of variously shaped bones of various
sizes. The long bones of the legs and arms, the irregular
bones of the hands and feet, the short bones of the fingers
and toes, the flat bones of the pelvis, skull, scapula, clavicle,
ribs, kneecap, and sternum, and the uniquely shaped bones
of the spine all articulate through a miraculous joinery into
the substructure of the human form.

The skeleton provides support, leverage, and in some
cases (the rib cage and skull, for instance) protection to the
vital organs of the body. The proportions we see in the
model are based largely on the proportions of the bones. A

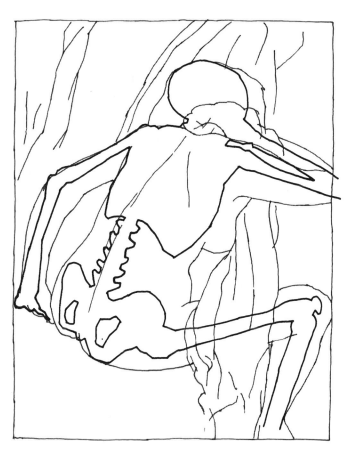

FIGURE 6.3
DRAWING (AFTER DEGAS) WITH
SKELETON SUPERIMPOSED.

useful exercise is to lay a sheet of tracing paper over a drawing you have done of the full figure and try to fit the skeleton into the drawn figure (Figure 6.3). You may find you have made the head the wrong shape to accommodate the skull, or the upper arm too short for the humerus, and so forth. This exercise can also test your understanding of the spine's articulation with the skull or the rib cage and pelvic bone's roles in supporting the torso.

Understanding the structure of the skeleton and its relationship with the outward appearance of the body is analogous to a carpenter's need to understand how the foundation and framing of a house relate to the house's surface appearance.

The Muscular System

Two important things to remember about the musculature system are (1) that muscles can pull, like stretched rubber bands, but they can't push and (2) that muscles quite often work in groups. Any simple action, such as picking up a book from the floor, involves both these principles.

While some muscles or groups of muscles are working, others are relaxed. A drawing that shows all the muscles in a state of tension will be inaccurate. You can be sure that the drawer didn't understand the working/relaxed principle that I've just described. Through being conscious of our

own bodies, and through empathy with others, we come to understand which muscles a model is using to accomplish a given pose and which are in a relaxed state.

Sex and Psychical Distance

Many people outside the art world (and some within) find it strange that artists and art students can draw objectively from the nude without becoming sexually aroused. It may be difficult for an outsider to understand the **psychical distance** normally brought about by a combination of the professionalism of the model, the serious intent of the people drawing, the difficult challenges of drawing, and

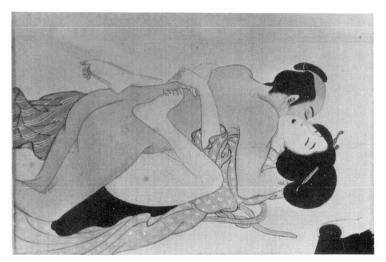

FIGURE 6.4
SCENE FROM PAINTED SCROLL, HOKUSAI
SCHOOL, C. 1830.

the typical separation of the model from the class by use of the model stand.

Of course, much art of Eastern as well as Western cultures celebrates the erotic aspects of nudity (Figure 6.4). The quality of eroticism has been present if not overt in much of traditional European art from the Greeks through the present. More often, though, Western artists have presented the unclothed human body not naked, but nude. **Nudity**, in art, refers to an idealized interpretation of the body through a demure pose (Figure 6.5) or through the distancing downplay of sensuality by way of forthrightness (Figure 6.6). Isabel Bishop's nudes (Figure 6.7) are straightforward studies of the human body in which sexual interest gives way to clear, direct descriptions of her subjects. In contrast to Bishop, Lucien Freud's works reveal the artist's strong interest in the genitals of his models, so that the viewer can't be objective (Figure 6.8). One is drawn in, repulsed, or both.

THE HEAD

Drawings of the head concentrate on the part of the figure that is the most replete with literary symbolism and association (the eyes, after all, mirror the soul), so it is the part of the human figure most difficult to draw with objectivity. We may be able to look at an elbow with the same detached and analytical eye we would use to examine a

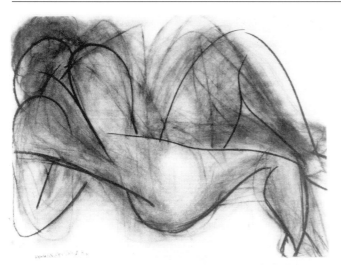

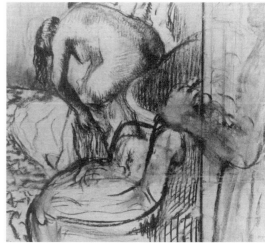

FIGURE 6.6
AFTER THE BATH BY
EDGAR DEGAS, C. 1900.
CHARCOAL AND PASTEL,
22" × 23 3/4".
(COLLECTION OF AYALA
ZACKS)

FIGURE 6.5
*RECLINING NUDE SEEN
FROM THE BACK* BY
HENRI MATISSE, 1938.
CHARCOAL ON PAPER,
23 5/8" × 31 7/8".
(COLLECTION OF THE
BALTIMORE MUSEUM
OF ART)

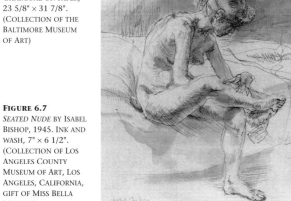

FIGURE 6.7
SEATED NUDE BY ISABEL
BISHOP, 1945. INK AND
WASH, 7" × 6 1/2".
(COLLECTION OF LOS
ANGELES COUNTY
MUSEUM OF ART, LOS
ANGELES, CALIFORNIA,
GIFT OF MISS BELLA
MABURY)

FIGURE 6.8
TWO MEN IN THE STUDIO
BY LUCIEN FREUD, 1989.
ETCHING, 9" × 8".

FIGURE 6.9
SIR RICHARD SOUTHWELL BY HANS HOLBEIN THE YOUNGER,
C. 1535. BLACK AND COLORED CHALKS WITH INK OUTLINES ON
PREPARED PAPER, 366 × 277 MM. (COLLECTION OF ROYAL LIBRARY,
WINDSOR)

stone. But when it comes to the head, we are often cowed by ideas like "facial expression" or "pretty" and "ugly." But it is the difficulty of drawing heads that is the challenge, along with the fact that some people simply love to draw heads.

Once we gain objectivity in drawing the head, we know that we can be just as objective about any subject—even those landscapes that we know we could get by with if we treated them more arbitrarily. The drawing of heads is a perfect training ground for anyone who wants to know when he or she is being arbitrary with proportions. You won't need an art critic to tell you if the nose is too long.

In the past, many drawings and paintings of heads were commissioned portraits (Figure 6.9). The argument that the camera ended the need for painted portraits is only partially true, at best, because such an argument assumes that since a Velasquez or a Van Dyke resembles a photograph, it is no more than a photograph. Portraits that are more than documentation fill the museums.

Commissioned portraits are certainly not as prevalent as in the past, but the likeness of a person still seems to me to be a valid and interesting subject for a painting or drawing. Noncommissioned portraits free contemporary artists to show special interest in psychological, formal, or stylistic interpretations (Figures 6.10 through 6.12).

As a subject, the head has a practical side since you al-

FIGURE 6.10
PORTRAIT OF A YOUNG MAN
BY PATRICIA GRAHAM
ARROTT, 1987. SILVERPOINT
ON ILLUSTRATION BOARD
PREPARED WITH ACRYLIC
GESSO PRIMER, 6 1/2" × 5".

FIGURE 6.11
*A GROUP OF FIVE
GROTESQUE HEADS* BY
LEONARDO DA VINCI,
1490. PEN AND INK
ON WHITE PAPER,
10 1/4" × 8".
(COLLECTION OF
WINDSOR CASTLE;
REPRODUCED BY
GRACIOUS
PERMISSION OF HER
MAJESTY QUEEN
ELIZABETH II)

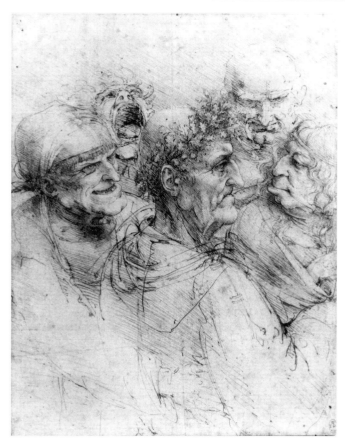

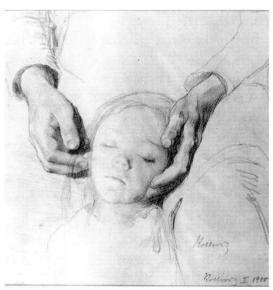

FIGURE 6.12
DOWNTRODDEN BY KÄTHE KOLLWITZ,
1900. PENCIL, 8 1/4" × 8 1/4".
(COLLECTION OF KUPFERSTICH-
KABINETT, DRESDEN)

ways have your own head to make a drawing of: a self-portrait. This is done, of course, with the help of a mirror. Or with the help of two mirrors, you can draw your profile or the back of your head. As a challenge, I suggest that you draw one self-portrait a day for thirty days. Later, you can pin up the drawings in chronological order and study how your conception of yourself evolved.

LANDSCAPES

Drawing a pure landscape is likely to encourage an abstract, intellectual approach to subject matter, because the elements of pure landscape are formal (Figure 6.13). Theodore Rouseau called these elements "the language of the ages." And it does seem to us that nature's qualities are eternal rather than temporal.

It may be this sense of the unchanging that draws many artists to the pure landscape, a subject that has become more and more difficult to find as the earth's surface becomes covered with one or another form of human structures. Artists who want to draw or paint pure landscapes often travel long distances or arrange their lives carefully to reach their subjects. Compounding this, landscape paint-

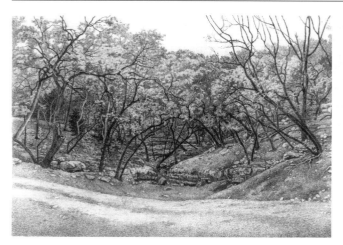

FIGURE 6.14
THE RATTLER BY ANNE C. WEARY, 1992. CHARCOAL ON PAPER, 10 1/8" × 15 1/8". (COLLECTION OF THE ARKANSAS ARTS CENTER, LITTLE ROCK)

FIGURE 6.15
CLOUD STUDY BY JOHN CONSTABLE, C. 1822. OIL ON PAPER, 18 7/8" × 23 1/4". (ASHMOLEAN MUSEUM, OXFORD)

ing is looked down on in some corners of the contemporary art world as a prosaic subject that belongs to the past.

I once heard the noted landscape painter Wolf Kahn give a tongue-in-cheek lecture titled "Ten Reasons Not to Paint Landscapes." His talk centered on the seemingly inappropriate nature of landscape painting in an art world dominated by fashionable rejections of formalism and romanticism. It occurred to me while listening to this lecture (which was his intention) that the pure landscape will no doubt be around as a viable subject for art when today's most popular art ideas are embarrassingly outdated.

A hidden quality in the history of landscape art is the way that artists have made the landscape visible by painting and drawing it into existence (Figure 6.14). Landscape artists have taught us how to see the earth in specific ways. Without Constable's works based on the English countryside (Figure 6.15), would we be able to see a meadow or a summer sky the way we do?

Urban Landscapes

If the elements of pure landscape are lasting, then the urban landscape offers the charm of temporality. It is filled with vehicles, buildings, clothes, and other manufactured

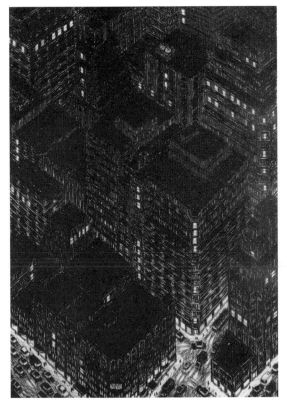

FIGURE 6.16
BROADWAY NIGHT BY YVONNE
JACQUETTE, 1982. BLACK CRAYON ON
VELLUM, 51" × 35". (COURTESY OF
BROOKE ALEXANDER, NEW YORK)

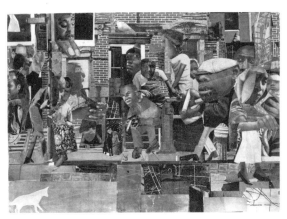

FIGURE 6.17
THE DOVE BY ROMARE BEARDEN,
1964. CUT-AND-PASTED PAPER,
GOUACHE, PENCIL, AND COLORED
PENCIL ON CARDBOARD, 13 3/8" ×
18 3/4". (COLLECTION OF THE
MUSEUM OF MODERN ART, NEW
YORK)

FIGURE 6.18
BALLET MECHANIQUE BY CHARLES
SHEELER, 1931. CONTÉ CRAYON
ON PAPER, 10 1/4" × 10".
(COLLECTION OF MEMORIAL ART
GALLERY OF THE UNIVERSITY OF
ROCHESTER; GIFT OF PETER ISELIN
AND HIS SISTER, EMILIE ISELIN
WIGGIN)

objects that are sure to become as dated as the horse and buggy. Everything in an urban landscape, even the vegetation and the rise and fall of the land, can be seen as artificial. But the temporality and artificiality are its magnets—the dynamic presence of a human-built environment draws artists to the city.

The personal visions in the works of Yvonne Jacquette (Figure 6.16) and Romare Bearden (Figure 6.17) give us individual readings of the complexities of contemporary life in New York. Earlier American painters, such as Charles Sheeler (Figure 6.18), saw that the industrial age had created an entirely new landscape—a place where great factories and grain elevators had taken the place of the cathedrals and ruined temples and other monumental buildings of the past. Sheeler celebrated what had happened as a positive change worthy of a brave new world. Other urban landscapists of the time, such as the painter George Grosz (Figure 6.19), were not so positive. Grosz saw a modern world where the mechanization of human beings in overcrowded cities was brought about by the economic systems of the Industrial Age.

New Viewpoints

It is the dissatisfied, searching eye of the artist that reports to the rest of the world how our environment, the planet earth, is looking (Figure 6.20). As they try to keep the record straight, artists raise grim new questions. And

FIGURE 6.19
THE GUILTY ONE REMAINS UNKNOWN (DER SCHULDIGE BLEIBT UNBEKANNT) BY GEORGE GROSZ, 1919. PEN AND BRUSH WITH BLACK INK ON CREAM LAID PAPER, 50.7 CM × 35.5 CM. (COLLECTION OF THE ART INSTITUTE OF CHICAGO, GIFT OF MR. AND MRS. STANLEY M. FREEHLING)

FIGURE 6.20
NORTH WIND IN MARCH BY
CHARLES BURCHFIELD, 1960–66.
WATERCOLOR ON PAPER, 47 1/2" ×
59 1/2". (OGONQUIT MUSEUM OF
AMERICAN ART, OGONQUIT,
MAINE)

science has found new viewpoints for us: We now know how the earth looks through the lens of a landsat camera in outer space (Figure 6.21). How will this macrocosmic view that has grown out of the technological age influence the way artists see landscapes (Figure 6.22)? Or is the landscape just another endangered subject? Certainly not to artists like Neil Welliver. His commitment to the land seems intensely personal, almost mystical; a quest for a universal understanding through sensate experience of the world he lives in on a daily basis (Figure 6.23).

FIGURE 6.21
PHOTOGRAPH OF PEKING TAKEN FROM 570 MILES
UP BY THE LANDSAT SPACECRAFT, 1975.

FIGURE 6.22
STAR FIELD I BY VIJA
CELMINS, 1982.
GRAPHITE ON PAPER,
21" × 27 1/2". (MCKEE
GALLERY, NEW YORK
CITY, COLLECTION OF
HARRY W. AND MARY
MARGARET
ANDERSON)

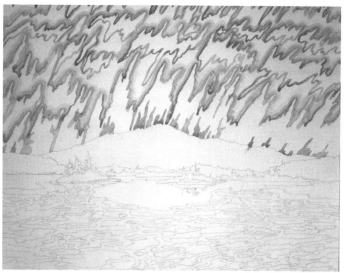

FIGURE 6.23
NORTHERN LIGHTS BY
NEIL WELLIVER, 1988.
GRAPHITE AND
WATERCOLOR ON
PAPER, 13 1/2" ×
16 1/2".

ANIMALS

Perhaps it is our relation to and differences from other animals that make them such irresistible subjects. Animals, whether feral or tame, live in a world we can't quite reach. This world from which we evolved, or strayed, depending on one's point of view, has a magnetic pull.

As subject matter, the animal world still provides a rich variety, albeit a variety that is shrinking as more species become extinct every day.

As exotic as animal subjects may sound, most of us have some contact with a pet or a neighbor's pet, and some of us live in circumstances where we can observe domestic or wild animals every day (Figures 6.24 through 6.28). If you think that animals are less accessible to you, remember that there is probably a zoo, a natural history museum, or an aquarium nearby where you can study at great length the look and behavior of a multitude of interesting examples of our closest relatives in the natural world.

Some artists have been quite content to do more than make close facsimiles of their animal subjects, while others, such as Texas artists David Bates (Figure 6.29) and Melissa Miller (Figure 6.30) have seen their subjects as metaphorical, often humorous. Other artists have combined animal and human aspects to create a hybrid monster, a possibility from the darker regions of the human psyche.

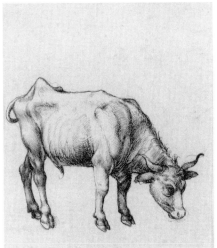

FIGURE 6.24
YOUNG STEER BY ALBRECHT DÜRER, C. 1495. PEN AND BLACK INK ON IVORY LAID PAPER, 17.5 × 14.0 CM. (COLLECTION OF ART INSTITUTE OF CHICAGO, CLARENCE BUCKINGHAM COLLECTION, 1965.408; PHOTOGRAPH © 1996 THE ART INSTITUTE OF CHICAGO, ALL RIGHTS RESERVED)

FIGURE 6.25
INSTRUCTIONS GIVEN TO HORSE FOR PLOWING CAMOUFLAGED BEAR BY JIM LOVE, 1973. PENCIL. (PRIVATE COLLECTION)

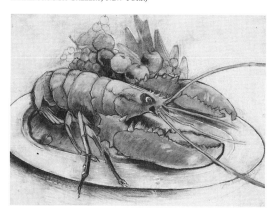

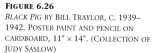

FIGURE 6.26
BLACK PIG BY BILL TRAYLOR, C. 1939–
1942. POSTER PAINT AND PENCIL ON
CARDBOARD, 11" × 14". (COLLECTION OF
JUDY SASLOW)

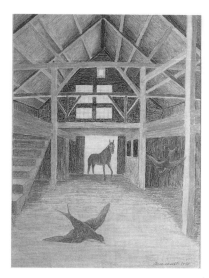

FIGURE 6.27
BARN SWALLOWS BY ANNE
ARNOLD, 1985. OIL PASTEL ON
PAPER. (PRIVATE COLLECTION,
COURTESY OF FISCHBACH
GALLERY, NEW YORK)

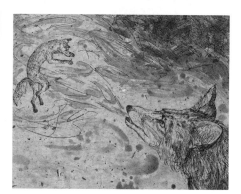

FIGURE 6.29
WEATHERVANE STUDIES BY DAVID
BATES, 1991. PENCIL ON PAPER,
30 1/4" × 44 1/2". (PRIVATE
COLLECTION)

FIGURE 6.30
ANIMA BY MELISSA MILLER, 1996.
ETCHING, 11 1/2" × 14 1/4".

SOCIAL COMMENTARY

Traditionally, drawing and printmaking have lent themselves well to social commentary. The drama of light and dark contrast, the media's simplicity and directness, and the multiple/original aspect of printmaking all seem to play to the needs of message making. From Goya's anguished reaction to the Spanish Inquisition to Sue Coe's despair over our woeful relation to domestic animals (Figure 6.31), artists have used graphic means to keep an eye on the imperfections of human nature.

Francisco Lucientes de Goya had been a successful court painter in eighteen-century Spain, but when he saw his fellow men committing atrocities that he had never dreamt humans capable of, he gave his work over to an intensely personal print documentation of the horrors of the Spanish Inquisition. He called this series of prints *The Disasters of War.* This group of works went unpublished for many years and were seen by his contemporaries as little more than caricatures (Figure 6.32). Today, two centuries later, the works are among our greatest art legacies.

Decades later, the French artist Honore Daumier championed the needs of his country's economic underclass in drawing and lithography, his favorite media.

In Chapter 5 I referred to the method and materials of Käthe Kollwitz's work. In content, her monumental graphic works often center on women: women as mothers and pro-

FIGURE 6.32
TAMPOCO, FROM *DISASTERS OF WAR* BY
FRANCISCO LUCIENTES DE GOYA, C. 1820.
ETCHING, 5 3/8" × 7 1/2".

tectors of children, women alone welcoming death, women as long-suffering survivors in a world torn apart by war. These are not neutral or happy works. They are dark and powerful comment on human life and its ultimate resolution in death (Figure 6.33).

Great works can and do grow out of adversity. Nowhere does this idea seem more true than the art of Mexico during the past 100 years. The government leaders of Mexico often ignored the suffering of the people brought on by impoverished conditions. During the last decades of the nineteenth century and the first decade of this century, Jose Guadalupe Posada (Figure 6.34) made hundreds of engravings on the subjects of the rich versus the poor, national events, demons, and death, all sold for pennies for popular consumption by the masses. Posada died in 1913, the year the Mexican Revolution began. Not until the 1920s was his work rediscovered and seen for its true genius. Among his earliest appreciators were a few painters, such as Diego Rivera and Jose Clemente Orozco (Figure 6.35), two of the finest Mexican renaissance artists working in the revived style of mural painting.

Deriving from the inspiration of the political fervor in the art of Mexico were the social protest artists of the United States. Painters like Ben Shahn and Jack Levine (Figure 6.36) made paintings and graphic works about the injustice and

FIGURE 6.33
WOMAN AND DEATH BY KÄTHE KOLLWITZ, 1910. BLACK CRAYON AND CHARCOAL ON LAID PAPER, 24" × 18 1/2". (NATIONAL GALLERY OF ART, WASHINGTON, D.C.)

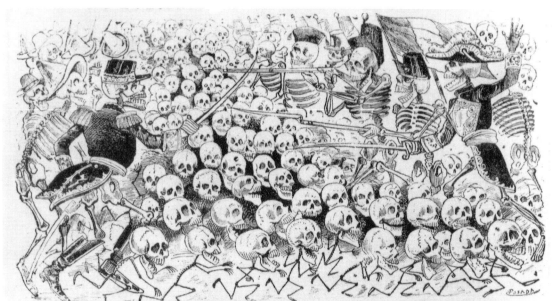

FIGURE 6.34
LA CALAVERA REVUELTA
BY JOSE GUADALUPE
POSADA. ENGRAVING.

FIGURE 6.35
HEAD OF QUETZALCOATL
BY JOSÉ CLEMENTE
OROZCO, C. 1932–34.
CRAYON ON TRACING
PAPER, 32 1/4" × 24 1/8".
(COLLECTION OF THE
MUSEUM OF MODERN
ART, NEW YORK)

FIGURE 6.36
THE BANQUET BY JACK LEVINE, C. 1942. PENCIL ON PAPER,
10" × 13 15/16". (COLLECTION OF ADDISON GALLERY OF AMERICAN
ART, PHILLIPS ACADEMY, ANDOVER, MASSACHUSETTS)

FGURE 6.37
*THERE ARE MANY CHURCHES IN
HARLEM; THE PEOPLE ARE VERY
RELIGIOUS* BY JACOB LAWRENCE,
1943. WATERCOLOR AND GOUACHE
ON PAPER. (COLLECTION OF THE
AMON CARTER MUSEUM, FORT
WORTH, TEXAS)

suffering they observed in their own country, especially during the years of the Great Depression.

The social problems of our own time, natural and global, have spawned artists whose works are decidedly political. From racial issues to the internal struggles in Third World countries, artists have used their voices to communicate social problems as they see them (Figures 6.37 through 6.39).

To encourage **conceptualizing**—that is, using the imagination in drawing—I suggest the following exercise in relation to social commentary. Pin a large sheet of paper, the larger the better, on the wall. In the spirit of the group drawing described in Chapter 4, choose a subject with social inferences, such as the homeless, and take turns with members of your class working on a drawing of the chosen subject. In a group drawing, we are often freer because we

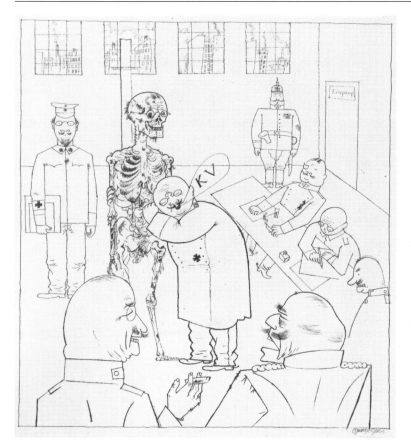

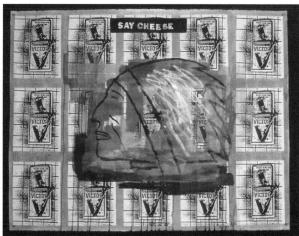

FIGURE 6.38
SAY CHEESE BY JAUNE QUICK-TO-SEE SMITH,
1995. MIXED MEDIA ON PAPER, 38" × 50".
(COURTESY OF STEINBAUM KRAUSS GALLERY,
NEW YORK)

FIGURE 6.39
THE FAITH HEALERS (KV =
KRIEGSVERWENDUNGSFAHIG = FIT FOR ACTIVE
DUTY) BY GEORGE GROSZ, 1916–17. PEN,
BRUSH, AND INDIA INK DRAWING ON IVORY
PAPER, 20" × 14 3/8". (COLLECTION OF THE
MUSEUM OF MODERN ART, NEW YORK)

don't feel quite so responsible for the final results. Having a subject anchors, directs, and emotionalizes the drawing.

SUMMARY

We need all the knowledge and self-knowledge we can get to "snare the subject matter of one's own intuition and life experience." In this chapter we've reviewed some of the traditional drawing subjects: the nude, heads and portraits, pure and urban landscapes, and social commentary. What subject(s) do you feel a special affinity for?

Some drawings are based directly on nature; others are conceptualized. As in earlier chapters, I encourage you to become familiar with, and proficient at, both approaches.

EXERCISES

1. By this point you should be familiar with drawing clothed and nude models and still life objects. Heads and landscapes may be less familiar to you, so I suggest applying the ideas you have learned—gesture, line and value, chiaroscuro, collage, and so on—to portraits and to both pure and urban landscapes. If the landscape idea still seems too broad, concentrate on details such as one tree, one rock, or, in the case of urban landscapes, a single building or car.

2. Animals move whenever they want to, so they are apt to be perfect subjects for gesture drawings. See whether someone in your class can bring in a pet for a session of quick poses.

3. Make a class trip to a local zoo, and start a sketchbook (more about sketchbooks in Chapter 7) of animals.

4. In relation to the idea of social commentary, make a series of drawings of people of a racial or ethnic group not your own.

GLOSSARY TERMS
conceptualizing
nudity
psychical distance

7 Play

MUCHACHOS, LOCKED
UP HERE IN SCHOOL
WE CAN'T DO
ANYTHING. LET'S GO
INTO THE STREET. LET'S
GO AND PAINT THE
LIFE IN THE STREET.
Frida Kahlo

One summer I found I had painted myself into a corner by having become too precious, too responsible, to really let anything happen in my work. I foundered a while, looking for an escape, before stumbling onto the idea of taking observation trips—or "reconnaissance trips" as a friend referred to them—before I painted or drew. I would walk around, drive around, or ride around on a bus with no purpose but to look at people, buildings, signage, cars—whatever was there. I would then return to my studio and draw anything I remembered from the trip. I kept various drawing materials on hand: pencils, crayons, ballpoints, colored paper, glue, scissors—anything I had accumulated. I never tried to make finished drawings. I left my work rough, even crude, so that I could easily leave one drawing for the next one.

Often I cut out individual figures and pinned them on one of the walls in my studio. By summer's end I had filled the wall with many layers of drawings, and my work had begun to move in a new direction. When my classes resumed in the fall, I simulated the observation trip approach with my drawing students, even though I no longer felt its validity for me. This idea did not help everyone in the class, but one new student, David Bates, had such a natural affinity for "play," as I began to call the process, that he continued to work in a related way long after the class was over (Figure 7.1). Perhaps he had found that this approach was more crucial to making art than some of the loftier concepts he had discovered before that time.

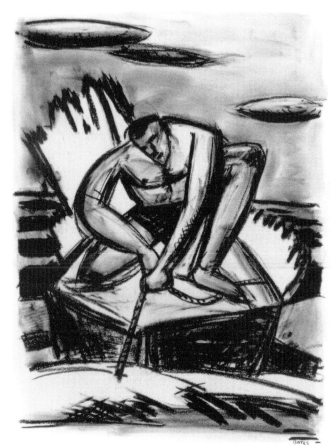

FIGURE 7.1
SHARK LINE BY DAVID BATES, 1990.
CHARCOAL ON PAPER, 40 1/4" × 26".
(PRIVATE COLLECTION; PHOTO BY LEE
CLOCKMAN)

PLAY'S COMMON DENOMINATORS

One of the reviewers of the previous edition of *On Drawing* criticized this chapter for not including more about "serious play" and mentioned the works of Juan Gris and Josef Albers, two artists I had not included. My response is that play *is* serious in that it isn't a giddy or frivolous thing, and it is more essential than "playfulness," but that the idea of serious play defeats the purpose and puts an artist right back into a structured corner where art grows stale. **Play** is letting go and making your own work, not looking over your shoulder, content to depend on yourself. To play is to use one's own voice, however wavering it may seem at first. The results of play can still be criticized, but the critic will have to search for more universal terms than the restricted ones used for most classroom work.

"Play" is often used to describe organized social activities requiring goals and involving competition with other individuals or teams, as in "playing" football. This idea of play may be helpful for promoting physical health, developing teamwork, or preparing for the world of business, but is such activity always "play"? If to play means to relax from a structured, disciplined routine for the sake of self-renewal, the answer is no. In art, play helps create a personal dialogue with one's medium, as well as with one's imagination and possibly with one's environment (Figures 7.2 and 7.3). It would not be easy to make the same types of discoveries through other means.

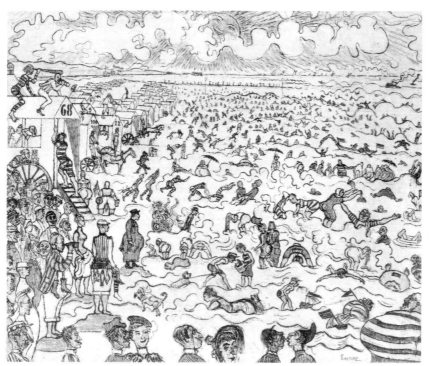

FIGURE 7.2
BEACH AT OSTENDE BY JAMES ENSOR,
1889. HAND-COLORED ETCHING, 8 3/8"
× 10 5/8". (COLLECTION OF THE ART
INSTITUTE OF CHICAGO)

FIGURE 7.3
DALLAS NIGHT BY GEORGE GROSZ, 1952.
WATERCOLOR, 24 3/8" × 16 7/8". (DALLAS
MUSEUM OF ART, FOUNDATION FOR THE ARTS
COLLECTION, ANONYMOUS GIFT IN MEMORY
OF LEON A. HARRIS)

FIGURE 7.4
JOMO/JOMO #14 BY DAVID MCMANAWAY, 1992.
MIXED MEDIA, 72" × 45". (COLLECTION OF DALLAS
MUSEUM OF ART)

ARTISTS AT PLAY

The element of play is present in all art, no matter how obscured. However, playing is occasionally the obvious center of a particular artist's work.

The artist I know who best exemplifies the idea of play as I have described it is Dallas sculptor David McManaway. In his early years as an artist, McManaway struggled between giving his energy to "serious" painting—that is, the painting values he had learned in art school—and taking a chance on his natural gift for finding and combining objects in his well-known Jomo boards (Figure 7.4). He derived the word *Jomo* from a movie scene remembered from childhood, in which a street vendor with a cart full of unidentifiable objects displayed a sign reading "Buy a Jomo." The word and the object it represents seem to have magical overtones, but as a full definition of McManaway's work, "magical" is too easy. It overlooks the importance the process has for him—the joy and pain he gets from letting life and art happen. He never forces a decision in his work, instead waiting patiently until it literally falls into place. Sometimes he waits for years.

FIGURE 7.5
DAVID MCMANAWAY IN HIS
STUDIO.

Too much emphasis on magic also overlooks his superb sense of craft as he struggles and agonizes over a subtle decision as to how a certain detail should be surfaced.

Play, in the context of McManaway's work and in the sense that I am using it, should not be mistaken for therapy, even though both could share a desired result: the correction of an undesirable condition. But while therapy may strive to turn one's head from some troubling circumstance, play, within art, is a subjective approach that never loses sight of the worthwhileness of the product while at the same time is not afraid to let unexpected things happen.

McManaway is intensely interested in the ultimate product that he extracts from his own archaeological digs into a culture that throws things away and loses things. A visit to his studio is time spent immersed in his most intimate thoughts and memories (Figure 7.5). It never fails to leave the visitor more open to his or her own capacities to make things, but never to make things happen. In other words, it leaves the person more open to play.

I include the following brief monographs of other contemporary artists for whom play is, or was, a major current in their work.

FEMME-MAISON BY LOUISE BOURGEOIS,
1946–47. INK ON PAPER, 23.2 × 9.2 CM.
(COLLECTION OF THE SOLOMON R.
GUGGENHEIM MUSEUM, NEW YORK)

"For me, drawing is a form of diary. I could not help but make them as a means to exorcise or deconstruct daily fears; they [the themes] are recurrent, precise, accurate, self-incriminating, and immediately regretted. Still you let them be, because the truth is better than nothing."

"The friend (spider, why spider?). Because my best friend was my mother and she was as clever, patient, neat, and useful as a spider. She could also defend herself."

Louise Bourgeois

Louise Bourgeois was born in Paris in 1911. Her childhood years have had a great impact on her personality and work, especially her relationship with an authoritarian father and a strong-willed mother.

Bourgeois studied math in college but abandoned it to devote her full time to the study of art. She attended the Ecole des Beaux-Arts but tired of its academic approach and enrolled in several of the art studios popular in Paris at the time. Her favorite teacher was the painter Fernand Leger.

She married an American art historian, Robert Goldwater, in 1938, and the couple moved to New York, where Bourgeois still lives today. During the 1940s Bourgeois was friends with Miro and other surrealists living in New York at the time, and their influence helped free her work from the constraints of school ideas, marriage, and motherhood.

She was also influenced during this period by the drawings of children and psychotics.

Bourgeois's work is entirely autobiographical. In imagery it concentrates on the body and body parts, the house, sexuality, and symbols of the past. Her work is essentially sculpture, but she has also been a prolific drawer, printer, and painter. In addition, she has designed costumes, done installations, and been the subject of many books, articles, and films. Although her work was largely neglected for years, it has been enthusiastically championed in recent decades in the great art centers of the world.

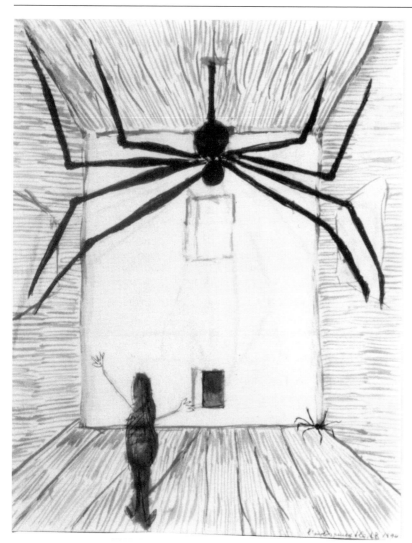

FIGURE 7.6
ARAIGNÉE (L'INDISPENSABLE) BY LOUISE BOURGEOIS, 1994. INK,
WATERCOLOR AND GOUCHE ON PAPER, 25.5 × 20.3 CM. (KARSTEN
GREVE GALLERY, COLOGNE, GERMANY)

"Marcel Duchamp and I were out walking together, when I noticed two snails clamped together, copulating. I pushed them off the stone ledge, then with my heel I crushed them into the ground. 'Why so severe?' Duchamp said to me. 'You don't need to be so emotional.'"

"The unconscious is my friend. I trust the unconscious."

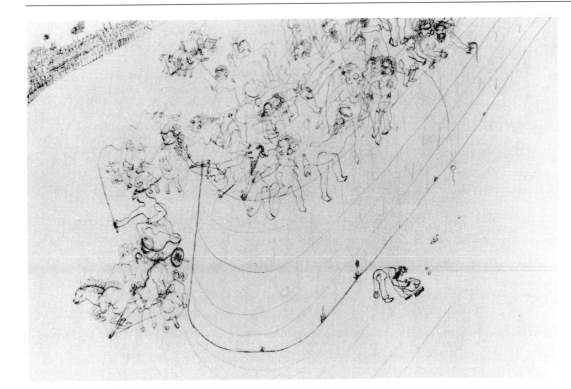

FIGURE 7.8
BEN HUR (DETAIL) BY ALEXANDER
CALDER, 1931. PEN AND INK, 22 3/4"
× 30 3/4". (COLLECTION OF MR. AND
MRS. ALVIN S. LANE, NEW YORK)

*"I seemed to have a knack
of doing it with a single
line."*

*"I think I was respected by
my playmates for what I
could make out of leather
with my tools and hands.
One time I even made an
electric light plug out of a
cork, a nail, and a piece of
copper wire. But after
drawing an enormous
spark from this apparatus,
I quit bothering electricity."*

Alexander Calder

Alexander Calder was born in the United States in 1898 into a family of visual artists. He, however, planned to be an engineer and in fact earned a degree in mechanical engineering. But his equally strong interest in art led him to study at the Art Students League in New York, principally under John Sloan. Although an American, Calder lived in Europe off and on during his productive years. His mobiles are his most widely popular works, but his full body of work is unusually extensive, including (in addition to a prodigious output of drawing, painting, and sculpture) toy making, book illustration, and, of course, the miniature circus—an ongoing project throughout his adult life.

FIGURE 7.9

CHARIOTEER BY ALEXANDER
CALDER, 1926–1931.
PAINTED WOOD, METAL,
WIRE, LEATHER, CLOTH,
STRING, AND RUBBER HOSE,
10 3/4" × 19 1/2" × 8 1/8".
(COLLECTION OF THE
WHITNEY MUSEUM OF
AMERICAN ART, NEW YORK)

*"They call me a
'playboy,' you know.
I want to make
things that are fun
to look at, that have
no propaganda value
whatsoever."*

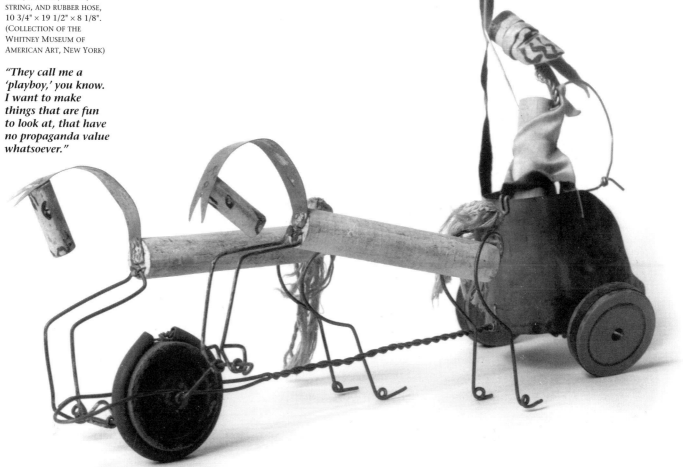

FIGURE 7.10
RUE DE L'ENTOURLOUPE BY JEAN DUBUFFET, 1963. OIL,
35" × 45 3/4". (COLLECTION OF GALERIE BEYELER,
SWITZERLAND)

*"I think that too conscientious a
scrutiny of an object distorts the
normal mechanism of looking, and I
believe that a painter should be very
careful to keep himself from over-
conscientiousness, should (a very
difficult kind of gymnastics) stick to
examining and representing things
without ever doing violence to that
distracted, confused state of mind,
that kind of hazy consciousness
perpetually in motion, which is man's
normal condition when the things
around him strike his attention. This
is why I have an aversion to drawing
objects from life."*

Jean Dubuffet

Jean Dubuffet was born in 1901 in Le Havre, France. He made several false starts in art pursuing traditional Western styles and only found his stride at age forty-five by letting his work follow his interests in naive art and "madness." His zealous belief in anti-Occidental ideas and disparaged values placed him at the front of the Art Brut movement. During the rest of his life, Dubuffet was monumentally prolific, producing many thousands of works in every conceivable medium, from oil paint mixed with ashes to butterfly wing collages. He was delighted by what he once called the "lively incompatibility" of materials that are not normally mixed, such as oil paint and water paint.

FIGURE 7.11
LA VIE AFFAIRE BY JEAN
DUBUFFET, 1953. OIL, 49 1/2" ×
75 1/2". (COLLECTION OF
GALERIE BEYELER, SWITZERLAND)

"The idea that there are beautiful objects and ugly objects, people who are endowed with beauty and others who cannot claim it, has surely no other foundation than convention—old poppycock—and I declare that convention unhealthy. I enjoy, at any rate, dissociating, to begin with, this pretense of beauty from any object I undertake to paint, starting again from this naught. Very often this cleaning suffices for the object to emerge suddenly wonderful—as it is in fact, and as any object can be. The beauty of an object depends on how we look at it and not at all on its proper proportions."

*"Collage technique is the
systematic exploitation of the
fortuitous or engineered
encounter of two or more
intrinsically incompatible
realities on a surface which
is manifestly inappropriate
for the purpose—and the
spark of poetry which leaps
across the gap as these two
realities are brought to-
gether."*

Max Ernst

Max Ernst was born in Cologne, Germany, in 1891, the second child of a teacher of the deaf and a painter. As a young man, he revolted against the civilization responsible for World War I, with its imbecilic destruction and its stupefying absurdity. Ernst's creative work in reaction to the horrors of war was, however, more a revelation of his personal emotional world—his dreams and fantasies. Through his experimental work in collage, sculpture, painting, film, and writing, he became a modern European master, his place in history already certain at the time of his death in 1976.

FIGURE 7.13
CHILD BY MAX ERNST, 1920.
MONTAGE, 4 3/8" × 5 3/4".
(COURTESY OF GALERIA SCHWARZ,
MILAN, AND GALERIE KRUGLER,
GENEVA)

"My wanderings, my unrest, my impatience, my doubts, my beliefs, my hallucinations, my loves, my outbursts of anger, my revolts, my contradictions, my refusals to submit to any discipline . . . have not created a climate favorable to the creation of a peaceful, serene work. My work is like my conduct: not harmonious in the sense of the classical composers, or even in the sense of the classical revolutionaries. Rebellious, heterogeneous, full of contradictions, it as unacceptable to the specialists—in art, in culture, in conduct, in logic in morality. But it does have the ability to enchant my accomplices: the poets, the 'pataphysicians and a few illiterates.'"

FIGURE 7.14
STUDY FOR THE BEWILDERED PLANET BY
MAX ERNST, 1942. 24 3/4" × 25 1/4".

"Tie an empty tin can to the end of a piece of string one or two yards long, drill a small hole in its bottom, fill the can with paint. Allow the can to swing to and fro on the end of the string over a canvas laying flat on the ground, guide the can by movements of the arms, the shoulders and the whole body. In this way amazing lines trickle on to the canvas. And then the game of free association begins."

FIGURE 7.15
GEOMETRIC MOUSE II BY
CLAES OLDENBURG, 1969–
1970. CARBON STEEL AND
ALUMINUM, 144" × 180" ×
84". (COLLECTION OF
SOUTHERN METHODIST
UNIVERSITY, DALLAS)

"A field, perhaps a slope of Geometric Mice, is envisaged to outlast us all— like the heads on Easter Island. Later visitors to this planet will wonder what purpose these figures served—if they were things or portraits or gods."

Claes Oldenburg

Claes Oldenburg was born in Stockholm, Sweden, in 1929 and emigrated to the United States as a child. He has been professionally active since moving to New York in 1956. His energetic production and breadth of ideas, crossing over pop art, conceptual art, primary sculpture, earthworks, and Art Brut, has no parallel in contemporary art. His ability to draw is at the heart of his achievement.

FIGURE 7.16
SYMBOLIC SELF-PORTRAIT WITH EQUALS
BY CLAES OLDENBURG, 1969. PENCIL,
COLORED PENCIL, AND SPRAY ENAMEL ON
GRAPH AND TRACING PAPER, 11" × 81/4".
(COLLECTION OF MODERNA MUSEET,
STOCKHOLM)

"The face is a cutout, like a mask, which is pasted on the diagram of the objects. The ice bag is also a cutout of different paper, pasted on. The face is divided in half vertically. One side shows the kindly aspect of the artist; the other, his brutal one. The body is introduced in the image of the face via the representation of the body's juices— the tongue (bringing out the insides)—which doubles as a heart and foot. The stare is partly the result of the working conditions of making a self-portrait—one hangs up a mirror and stares into it—but also emphasizes the artist's reliance on the eyes. The 3 1/2" on the forehead is left on as a reminder of my concern at the time with measurements of patterns. The Ice Bag on the head signifies that the subject was on my mind. It doubles as a beret—attribute of the artist."

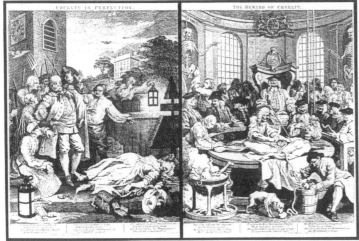

FIGURE 7.18
FROM *THE FOUR STAGES OF CRUELTY* BY WILLIAM HOGARTH,
1751. ENGRAVING.

COMICS: THE PICTURE STORY

Picasso loved American comic strips, but art historians and art critics have not been generous toward the **picture story** until recently, when works by avant garde comics artists—Art Spiegelman and R. Crumb, for example—have found their way onto the walls of some of our most august art institutions. Despite these recent inroads into high art, cartooning has been possibly the most despised, albeit one of the most popular, of the popular arts.

The comic strip evolved from the European broadsheet (Figure 7.17), which often provided the masses with moral and political propaganda—so comics have never been 100 percent "comic." The broadsheet was a mass medium intended for wide consumption. It was a product of the printing press. Its purpose was almost always to tell a moral story related to a specific political event.

William Hogarth, in his serial works such as *Rake's Progress*, brought aesthetic respectability to pictorial narrative (Figure 7.18), but his followers were no more than followers. They did not manage to keep alive the creative fire he started.

The work of Goya (Figure 6.32) transcended the limitations of the picture story while being, nevertheless, a product of its idea.

As discussed in the previous chapter, Posada revived the moralistic picture story for communicating with the Mexi-

FIGURE 7.19
RETABLO BY EDUARDO BENEGAS, 1961. OIL ON MASONITE,
8 7/8" × 11 3/4".

FIGURE 7.20
FROM *BUSTER BROWN GOES SHOOTING*
BY R. F. OUTCAULT, 1905.

can working class. Even the Mexican **retablo** (Figure 7.19), while not normally a serial picture, tells a story with pictures and words, which is one of the essential qualities of the comic strip.

The American newspaper comic strips, or "funnies," first flourished in the late nineteenth and early twentieth centuries, with titles such as *The Yellow Kid* and *Buster Brown* by R. F. Outcault (Figure 7.20) and *Little Nemo in Slumberland* by Winsor McCay. Even though both comic strips and their offspring, comic books (born in the 1930s), have been

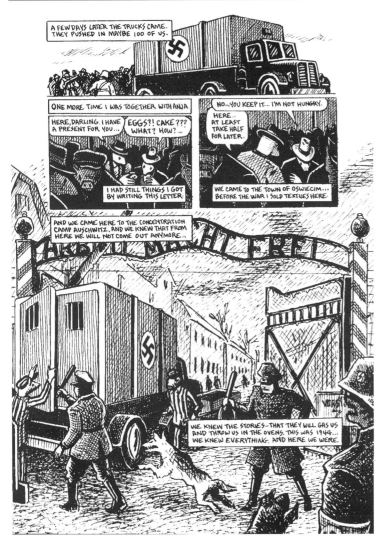

FIGURE 7.21
FROM *MAUS: A SURVIVOR'S TALE* BY ART SPIEGELMAN, 1986. (PANTHEON BOOKS, 1986)

considered baneful presences in American culture by parents, intellectuals, aestheticians, and cranks, this has not stopped their evolution toward a legitimate medium, often with deep social concerns. No better example can be mentioned than art spiegelman's *Maus I* and *Maus II*. These books tell the story of his parents' experiences in a Nazi concentration camp, their ultimate survival, and the long-term effect on art's relationship with his father. In this epic tale, the Jews are portrayed as mice and the German soldiers as cats (Figure 7.21).

The themes of the more critically lauded comics can range from Eric Drooker's apocalyptic view of a flooded New York City (Figure 7.22) to Lynda Barry's bittersweet remembrances of childhood and adolescence in the midst of American culture (Figure 7.23).

Perhaps R. Crumb is the best known and most controversial of today's cartoonists. He comments on some of the more grotesque foibles of human nature, often through blatantly pornographic picture stories. But this is only one

FIGURE 7.22
FROM *FLOOD! A NOVEL IN PICTURES* BY ERIC DROOKER, 1992. (PUBLISHED BY FOUR WALLS, EIGHT WINDOWS, NEW YORK/LONDON)

FIGURE 7.23
FROM *DOWN THE STREET* BY LYNDA BARRY, 1988. (HARPER & ROW, 1988)

"OTTLA LITERALLY CARRIES ME ON HER WINGS THROUGH THIS DIFFICULT WORLD."

In his personal life, women also provided a REFUGE from his father, the chief bearer of this Herculean task being his younger sister, Ottla.

FIGURE 7.24
FROM *INTRODUCING KAFKA* BY R. CRUMB, 1994.
(KITCHEN SINK PRESS, 1994)

side of Crumb's work. He has a breadth that has won him a largely dedicated following (Figure 7.24), while his pictorial peregrinations into sado-sexuality have deeply offended others. Crumb, like some of the other avant garde comics artists, "weaves the line," as one critic put it, "between fine *aht* and gutter comics like a drunk taking a sobriety test."

A picture story, whether in the form of comics or children's books, has the gargantuan task of clear communication. The viewer is led from picture to picture, from top to bottom, from front to back, in a compelling, coherent fashion.

THE BLANK PAGE AND YOU

So much of a beginner's class in drawing deals with direct perception of objects, usually still life objects or life class models. The discipline and knowledge derived from drawing directly from life has no substitute. If you are an art major, you will no doubt be drawing from things for the full time you are in school and possibly afterward. But as important as life drawing is, it is equally important not to fall in the trap of thinking that drawing from life is the beginning and the end and can supplant any other approach to making art.

Drawing from the imagination is equally important in developing your full powers as an artist (Figure 7.25). This chapter about artists whose imaginations come first should

be taken as a gentle nudge. The ability to develop works without a model in front of you is a quality often lacking from the works of even many of the successful artists working today. The idea of working from the imagination is often avoided in highly structured art schools. As I pointed out in Chapter 4, many of my own students, when asked to draw without a model, were simply lost as to how to proceed. They were afraid of the blank page. I often resorted to the idea of a group drawing, as I described in that chapter. We took turns working on a drawing, usually with a theme, talking it through many different stages. When the drawing began to get too tight, we turned it upside down or on one of its sides and proceeded.

There is *some* relationship between the approach I describe and the automatic writing and free association of the surrealists in painting and literature, and even some relationship to the process of doodling (Figure 7.26). However, this comparison can't be taken too far. The intent of much doodling and automatic work is narrow: the activity is an end in itself with none of the conscious concern for composition that I invariably encourage.

KEEPING A SKETCHBOOK

An art school in London asks applicants to submit a sketchbook—not selective pages, but a complete sketchbook. Whoever came up with this idea knew how reveal-

FIGURE 7.25
GREETINGS FROM AN ISLAND BY FRANCES HYNES, 1995. WATERCOLOR, GOUACHE ON C. M. FABRIANO, 22" × 30". (COURTESY OF THE ARTIST)

FIGURE 7.26
DOODLES FROM PAY PHONE.

FIGURE 7.27
SKETCHES BY REGINALD MARSH, 1928, 1930.
SKETCHBOOK #179. BLACK CHALK, PEN AND INK.
(COLLECTION OF THE METROPOLITAN MUSEUM OF ART,
BEQUEST OF FELICIA MEYER MARSH)

ing a full book would be. I empathize with the prospective students who have to decide what to send. Keeping a sketchbook is no doubt a good habit that some artists never acquire. In devoted hands it becomes a visual diary, able to record the most ephemeral thought or event (Figure 7.27).

Keeping a sketchbook requires always having usable material on hand. And the material (pens, pencils, colored pencils, crayons, and so on) would need to be practical in size and weight and manageable in tight or windy circumstances that may not allow you to spread out as you can in a studio.

FIGURE 7.28
Sketchbook pages by Otis Dozier,
1941. (Courtesy Valley House
Gallery, Dallas, Texas)

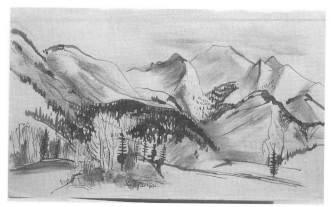

I have known several artists who make special trips for the sake of finding interesting material for their sketchbooks. Texas painter Otis Dozier literally traveled the world, filling a staggering number of sketchbooks during his travels (Figure 7.28). His books are now a part of the Dallas Museum of Art. They record his trips to India, Japan, France, and England, as well as the mountains of Colorado, the bayous of Louisiana, and the Pueblo Indian reservations of the Southwest, to name but a few of his haunts. Dozier's sketchbooks were an end in themselves as well as his research material for a prolific output of paintings.

SUMMARY

All work and no play makes Jack, or Jill, a dull artist. To play is to give yourself the freedom to do your own drawings. Criticism of such work requires a more universal standard than criticism of classroom drawing. To play means to let things happen—to overcome conditioned responses, preconceptions, inhibitions.

Play is central in some artists' work. I have given a glimpse at the work and thought of five such artists: Louise Bourgeois, Alexander Calder, Jean Dubuffet, Max Ernst, and Claes Oldenburg.

We also saw in this chapter that play can lead to wonderful picture stories, drawing from the imagination, and idea-filled sketchbooks.

EXERCISES

1. Make an observation trip, of the type I describe at the beginning of the chapter. First, make a conscious effort to retain all of what you see. Go back to your workroom or classroom immediately after your observation trip. Start by putting down anything you can remember without worrying about page composition or a unified picture. Fill up page after page with every movement, image, word, or phrase you can recall from the trip. Be rough with your materials. If you are too careful, you will inhibit the method, your memory, and your attitude. Let go, let things happen, and have fun. Don't think about your drawing's appearance. Let it be ugly, or clumsy, or childlike. See how strong your marks can be. Break all the rules. Be silly. Be an iconoclast. Don't concern yourself with whether or not someone else has worked in a similar way. You are making drawings in your own way.

2. Sketchbooks can be filled from cover to cover or started on any page and continued arbitrarily until the book is filled. You can "play" with a sketchbook by turning it upside down, using it as a verbal as well as a visual diary, making a drawing that is two pages large instead of one, and deliberately drawing with a variety of materials (wet, dry, color black and white, collage, mixed media). The sketchbook can be a resource for works in other media as well as a wonderful thing in itself.

GLOSSARY TERMS

picture story

play

retablo

8 Criticism

WE MAY THINK WE ARE
JUDGING A DRAWING,
BUT IT CAN HAPPEN
THAT THE DRAWING IS
TAKING A MEASURE OF
US. IF OUR PERCEP-
TIONS HAVE ATROPHIED
OR GONE ASTRAY, THE
DRAWING WILL LEAVE
US IN NO DOUBT OF IT.
John Russell

Looking at art and listening to others talk about art are important steps in the development of a critical sense. Most art schools provide built-in activities that encourage talking and listening: symposiums, colloquiums, seminars on art or related subjects, discussion classes, or—perhaps best of all—a local "watering hole" where students, teachers, and area artists congregate to talk.

ESTABLISHING DIALOGUE

Always take advantage of circumstances encouraging **dialogue;** when you enter a conversation, take chances. Be candid, even when you feel uncertain about an idea. The best way to resolve your doubts is to get them out in the open. Your candidness and courage will help generate a more spirited discussion than an inhibited, leave-it-to-others attitude. Remember that your reason for taking part in discussions, other than the fun of it, is to learn as much as you can about what you are looking at when you look at art. Through talking and listening, you learn to articulate your thoughts and add to your knowledge and understanding.

If you can find no obvious source for art discussions, start a student group as an arena for voicing your ideas and listening to others talk about their ideas. Such a group could also serve as a forum for inviting teachers or other informed guests to speak and lead discussions. The group should welcome a diversity of

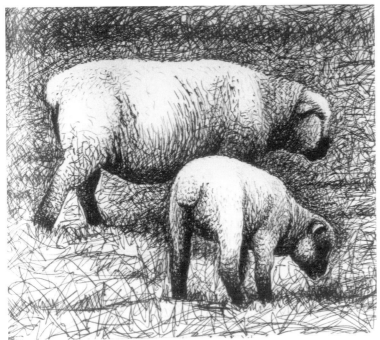

FIGURE 8.1
LOOK TO ART BOOKS IN YOUR LIBRARY FOR SOURCES OF
INSPIRATION. FROM *HENRY MOORE'S SHEEP SKETCHBOOK*
BY HENRY MOORE AND KENNETH CLARK
(LONDON: THAMES AND HUDSON, LTD., 1980).

personalities and opinions. This is the best assurance against its turning into a social "in" group, losing track of its reason for being: dialogue.

Even more important than talking and listening is for you to look at art. Browse through the beautiful art books in bookstores and check some out from the library (Figure 8.1). Start a collection of books on art if you can afford it. Keep a calendar of local, national, and international art events. Go to gallery shows and, when you have a chance, artists' studios. Look. Look at art-fair work, motel seascapes, paintings on velvet, second- and third-hand avant garde. By becoming familiar with a great range of objects done in the name of art, you will clarify and strengthen your own ideas about what quality really is and isn't. Know when you like or dislike a work, regardless of consensus of opinion. At the same time, listen to others' opinions. Don't close your mind. Your chances of forming enlightened opinions, of being comprehensively informed, are greatly improved by listening with an open mind to knowledgeable people. Listen not to agree, but to weigh and assimilate.

Reading about art is an obvious method of developing a critical sense. Through reading, you establish dialogue with a far larger sphere than a circle of intelligent friends. As with listening, don't read to agree—read to understand. If necessary, you must vigorously disagree. Ben Shahn, in his famous book *The Shape of Content*, suggests that an art student read everything except reviews. Shahn, like all of us, may have had painful experiences with reviews of his own work, and in that light I can understand his advice. I will disagree, however, and suggest that you do read reviews as well. Of course, you should not take them as gospel, but

none of us do ourselves justice when we hide from ideas that we fear. Isolation from painful ideas may bring a feeling of security, but it is the same security offered by being in prison.

CLASS CRITIQUES

A **class critique** calls for a sizable pinning board on which a group of drawings may be displayed for the whole class to see. Ideally, a critique involves everyone; in other words, each person tries to give his or her thoughts candidly and directly about any work or works under discussion. Each person must also hear others' opinions of his or her work, no matter how flattering or condemning. Critiques often become personal events, not only because you are finding out how your works are getting through to others but because you are saying what you think of other people's work. All is out in the open and up for review. Nothing is out of sight. Nothing is unmentionable. Only in this light can true criticism take place.

When looking at pinned-up drawings, you can ask (and answer) some of the following questions: Do these drawings depend on gimmicks? Is technique emphasized over form? Are they honest works? Have the drawings been too influenced by a famous artist or by a member of the class? Who are the influences? Are there obvious problems with process? How can the process be improved? Do the draw-

FIGURE 8.2
CRITIQUING SESSION WITH VISITING ARTISTS MALCOLM MORELY, ARCHIE RAND, AND HARMONY HAMMOND AT VERMONT STUDIO CENTER.

ings show energy? skill? too much skill? laziness? What is the predominant mood of the drawings?

Invariably, a particular set of drawings will provoke a particular set of questions. Don't depend just on my list. These are only suggestions. Stay alert. Devise your own comments and inquiries to fit the work in front of you.

GUEST CRITICS

A guest critic stretches the critical imagination by providing fresh input and by serving as a sounding board for your ideas (Figure 8.2). A guest can make a class critique a more exciting event, even if the guest is no more glamorous than an advanced student or another teacher on the faculty. *Never* pass up an opportunity to engage in dialogue with a visitor. Not only will the experience help you see yourself in a different way, but you are likely to receive

affirmation of some of the most basic visual tenets you have learned from your teachers and peers.

Even though you should show a guest proper courtesy (if for no other reason than that the instructor may want to invite him or her back), don't act as if every word he or she utters is heavenly law. If you want to defend a certain point, why not? You may be right. And besides, the idea of critiques and guests is for *you* to learn more about drawing, and you may be able to learn more through confrontation than through silence.

PAIRED WORKS FOR COMPARISON

It is often useful to compare pairs of works to enrich students' understanding of art. Through comparison we can show the individual nature of each work more pointedly than would be possible if each work were presented in isolation.

For a fresh view of your work, why not compare a photograph of one of your pieces with a reproduction of a well-known work in the same medium?

A Grunewald Drawing Compared to a Rouault Print

The Bible is the source of the works in Figures 8.3 and 8.4, and both artists were fervent Christians. While both works express the universal theme of suffering, it is related specifically to the passion of Christ. Matthias Grunewald's *Crying Angel* represents an open, unabated state of grief. Georges Rouault's *Virgin of the Seven Swords* shows suffering long endured and a willingness to accept any fate.

The two works are related by general content but are singularly disparate in approach. Grunewald lived in a time and place (Germany during the Northern Renaissance) when artists celebrated a newly acquired ability to make dazzling illusions of the everyday world but were still close to the late Gothic's spiritual attitude—hence, the religious fantasy of the drawing. And although Grunewald's three-dimensional view of the human head might impress us, it is not the illusionistic aspect of the drawing that gives it its enduring appeal. A lesser artist, using the same degree of illusionism, might make a maudlin and slick work. The drawing's quality comes from its masterful synthesis of idea, illusion, and form. The dramatic scale of the head to the space of the page is softened, balanced out, by allowing some of the edges—the curls at the top of the forehead, for instance—to almost disappear into the light of the page. The delicacy (but certainty) of the transitions from value to value in the areas of face and hair also soften the impact of the large head with open mouth. This feeling of air and light in the drawing betrays Grunewald's painterly sensibilities.

The line moving up through the right side of the face

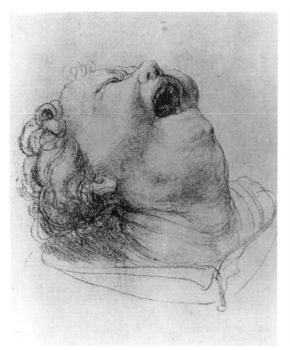

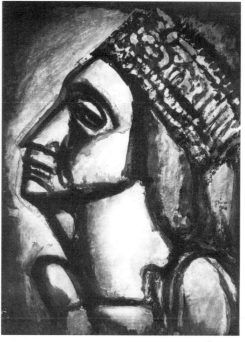

FIGURE 8.3
CRYING ANGEL BY MATTHIAS GRUNEWALD, C. 1515–1516. BLACK CHALK
HIGHLIGHTED WITH WHITE BY BRUSH ON LIGHT YELLOW-BROWN PAPER,
9 5/8" × 7 7/8". (COLLECTION OF KUPFERSTICH-KABINETT, BERLIN)

FIGURE 8.4
VIRGIN OF THE SEVEN SWORDS BY GEORGES ROUAULT, C. 1922–
1928. ENGRAVING, 23" × 16 1/8". (COLLECTION OF THE NATIONAL
GALLERY OF ART, WASHINGTON, D.C.)

and around the forehead and first few curls of hair gives a
superb shape to the upper background, which shows that
Grunewald was as masterful with line as he was with tone.
Repeating the double curved line of the open mouth in the
curl showing above the forehead establishes a rhythmic

motif. The same movement is echoed in the hair, the ear,
the cheek, the chin, and the gestural line on the right side
of the collar. The drawing contrasts the gently curving line
across the bottom of the page with the energetically curved
contour line of the face.

It is safe to assume that this work was not drawn as consciously as my words make it sound. The quality of the drawing must be seen as spontaneously produced—as a synthesis of intuition and knowledge, discipline and expression. Its quality is tied not only to Grunewald's talent but to his training and culture.

Obviously, Rouault's print is a product of a very different time and place, in which illusionism had lost not only its challenge but also its magic. Naturalism no longer served the needs of artists living in a world that had become smaller in a very short time because of improved communication. The significant painters of Rouault's time (the early twentieth century) left the objective world to photographers and moved toward subjective or nonobjective aesthetic positions. In his work Rouault evolved to an almost primitively direct means of emotionalizing the subjects and the structure of his art. The prints in his *Miserere* series (which were first done as ink drawings) show his mature approach at its fullest.

Rouault, like Grunewald, shows his painterly talents in the soft transitions of tones. But unlike Grunewald, Rouault reinforces his work with heavy, brutal lines that evoke the leaded lines of stained glass. The features of the face and the anatomy of the neck and shoulders have been simplified and reduced to the most basic system of volumes. The system is then used as a structural building method manipulated to form the awesomely direct design that satisfied Rouault's expressive needs.

It is important to remember that Rouault's nonnaturalistic approach was a matter of choice rather than necessity and that his mature expression passed through a naturalistic phase—it did not appear all of a sudden, fully matured.

Although it is impossible for anyone to say whether one of these two works will outlast the other, we must acknowledge that both artists were masters of their means; both works are strong in their individual ways, and both are honest and learned. A work is inevitably a product of its time, but the strong work transcends its time and remains meaningful to future viewers because of its universality and levels of appeal. The Grunewald drawing has passed this ultimate test, while the Rouault has yet to be tested.

A Philip Guston Drawing Compared to a Willem de Kooning Drawing

Two artists of the same school (Abstract Expressionism), same country (America), and same time frame made the two drawings in Figures 8.5 and 8.6. The two artists had many of the same friends. We are aware right away, however, that the two works have different visual imports. The Guston drawing is intimate and suggestive. The squiggles of lines are poised in the horizontal space in measured relationship to each other. Although there are no identifiable images in

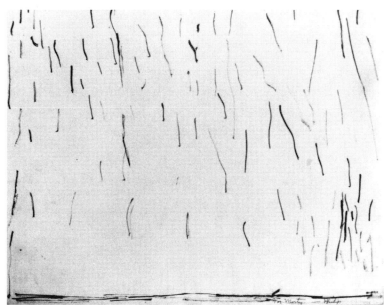

FIGURE 8.5
UNTITLED DRAWING BY PHILIP GUSTON, 1951. INK ON PAPER,
17" × 24 1/2". (COLLECTION OF MORTON FELDMAN)

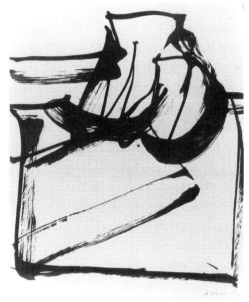

FIGURE 8.6
FOLDED SHIRT ON LAUNDRY PAPER BY WILLEM DE KOONING,
1958. INK, 16 7/8" × 13 7/8".

the work, we sense the presence of a group of objects. Figures? landscape forms? These suggestions of figurative forms appear and disappear with examination of the work.

If we look at the drawing by de Kooning, we find some of the same sense of suggestion as in the Guston (which raises the old question of whether it is possible to create a totally nonobjective work), but de Kooning's forms are far more energized than Guston's. De Kooning has clearly divided

the page into chunks of space forming an overall pattern. Our eye, rather than lingering suspended in the center of space as with the Guston, moves throughout the page. The bold movements of the drawing provides tracks; we cannot linger long in any one spot along the tracks. We remain conscious of the rectangular form of the page itself and of the highly structured division of the rectangular space.

In both works, the illusion of three-dimensional space

exists but is shallow; thus, the two-dimensional plane takes on the illusion of a thick slab of space in which the forms interrelate. Both works are poetic; the Guston is a soft, lyrical work in comparison to the cutting, stinging quality of the de Kooning. In comparing these two drawings, we do not compare good and bad, or even good and better; we note the similarities and the differences in related works, each based on a respected aesthetic view. The more we know of each artist's work, the more at home we feel in the presence of his ideas.

A Picasso Drawing Compared to a Picasso Drawing

Pablo Picasso was able to move through the major ideas of traditional Western art, venture into the forms of other cultures, and still produce drawings so much his own that identification is unnecessary. Obviously, I could have chosen more disparate works than those in Figures 8.7 and 8.8 to compare. Instead, these are two drawings linked to cubist space but created almost thirty years apart. Each makes use of angular figurative forms, fractured space, and evocations of earlier Western painting. As with the Guston/de Kooning comparison, I do not need to find good or bad—both drawings are respected in the master's body of work. The only task is to point out the intentions in each work and to discuss the methods used to achieve these intentions.

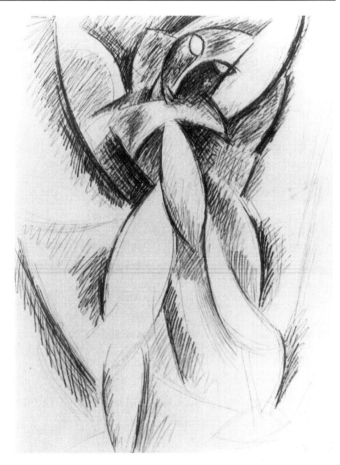

FIGURE 8.7
STUDY FOR *STANDING NUDE* BY PABLO PICASSO, 1908. CONTÉ CRAYON, 33" × 25". (COLLECTION OF THE MUSEUM OF FINE ARTS, BOSTON)

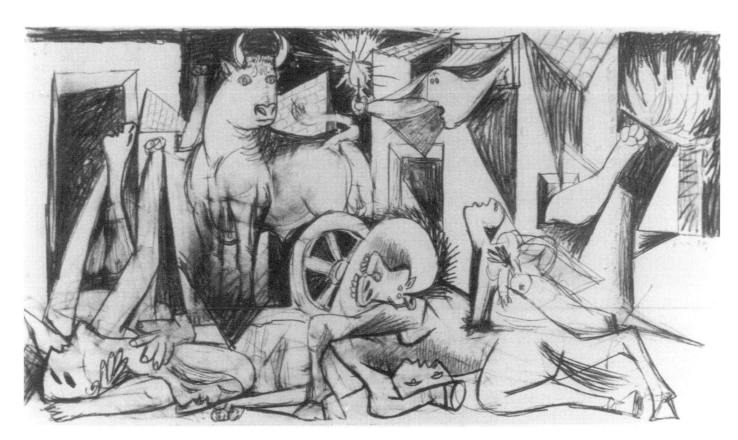

FIGURE 8.8
COMPOSITIONAL STUDY FOR *GUERNICA* BY
PABLO PICASSO, 1937. PENCIL ON WHITE PAPER,
9 1/2" × 17 7/8". (COLLECTION OF MUSEO
NATIONAL DEL PRADO, MADRID)

In the study for *Standing Nude* (Figure 8.7), Picasso's work is still in the first flowering of Cubism. The human figure has been converted to elliptical and ovoid shapes, carving out a space similar to that of African sculpture. The implications of the figure's distortion seem to be more for structural than expressionistic ends. The slightest echo of the melancholy mood that pervaded Picasso's rose- and blue-period figures exists, but his use of space to create dynamism through structure creates the dominant mood.

The study for *Guernica* (Figure 8.8) shows a more mature Picasso; the richness of his expressive means reflects his maturity. The ability to structure space dynamically is now a matter of course to be used to strengthen other expressive ends. The reduction of human figures, animals, and the inanimate objects and spaces in the environment to simple geometric forms is more overt than in the first drawing, and the showing of various spatial points of view within one space is more overtly disjunct. The distortion of the faces and bodies is no longer a matter of proving that it can be done, but now provides a means for expressing the torture and violence resulting from military force, the total disruption of life on earth brought about by war.

Picasso never forgot his priorities as an artist. In the *Guernica* study, he orchestrated straight and curved forces, positive and negative volumes, three-dimensional space condensed to fit a two-dimensional plane, contrasting gestures, and lines of motion to lead the viewer's eyes to the periphery of the plane but always back into the meaty central substance—the pyramid whose baseline is made up of fallen figures and fallen horse and whose apex is the hand-held light in the upper center.

Both drawings show disjunct movement through space. Both works show a strong vertical force, but both escape being static through a slight axial tilt, as well as a tension in the spatial relationships that pull at the forms and torture them into a new state of life.

SUMMARY

The critical sense is developed through dialogue, through talking and listening. When you enter into discussions about art, be candid. Only your honest feelings and opinions are worth articulating.

Look at art. Read about art. Strive against isolation.

A class critique with a visiting critic is an exciting way to learn about drawing, art, and philosophy and to have your own ideas examined.

Discussion of quality is always difficult but beneficial. Comparing pairs of works is a more pointed way to get at what each work is about than discussing them one at a time would be.

EXERCISES

1. Attend a well-publicized gallery show and make notes on some of the pieces. Seek out reviews of the show, and compare your notes with what the reviewer had to say. Did the review give you any insights?

2. Participate in a critiquing session with a group of fellow students. Follow the guidelines presented in this chapter.

3. In the spirit of the paired works for comparison, choose two drawing qualities (the carved look versus the modeled look, for instance) and make a brief presentation to your drawing class. If you have trouble thinking of a comparison, perhaps your teacher could suggest some from which to choose.

GLOSSARY TERMS

class critique

dialogue

Epilogue

"DRAWING IS THE

HONESTY OF ART."

*Jean Auguste
Dominique Ingres*

As you have learned by now, drawing is not for the timid. You may have come across a "how to" book that lays out a step-by-step method meant to prevent failure, but you'll soon find that it also prevents success. The best that a safe approach can do is to habituate a young artist's work into perpetual mediocrity.

The worthwhile drawing process takes a hazardous route guided by the most general of concepts and goals. Sometimes the drawing ends in disaster, and sometimes it is brilliantly successful, and the final combination of bold decisions and subtle suggestions that make up the successful work are born, in large part, of subjective, spontaneous discovery. The processes I have described for you, whether gesture drawing, line work, values studies, or play, will not translate into a method that moves from A to Z in rational steps. It is through the gamble, the willingness to make mistakes, that we keep our work alive and growing.

Glossary

Aerial perspective refers to the phenomenon that causes faraway objects to seem less focused and lose their warm colors due to the effect of miles of blue atmosphere.

Blind contour drawing is a popular exercise that requires the drawer to look only at the object he or she is drawing—never at the drawing itself. The drawer pretends to touch the edges of the subject with the point of a pencil or other drawing tool; hence, blind contour drawing is a tactile exercise.

Bristol board is a smoothly finished drawing paper often sold in multiple plies so that it has the thick, stiff quality of cardboard.

Chiaroscuro is an approach to drawing on toned paper in which the lights and darks are drawn in with black and white materials and the paper serves as a middle value.

Class critiques are discussions of student work by a teacher, members of the class, and perhaps a guest critic.

Cold-press papers are papers prepared so that the surfaces remain rough—i.e., "toothy."

Compressed charcoal is a drawing material made from concentrated charcoal dust held together by a binder.

Conceptual, as opposed to perceptual, refers to the quality of visual imagining rather than direct observation.

Conté is a dry, hard drawing material sold in small, bar-shaped sticks. Its capacity for creating tones makes it appropriate for light and dark studies.

Counterbalance refers to the balancing of a movement, weight, or other formal element with an opposing one.

Cross-hatching is a method of creating light and dark by laying a series of lines drawing in one direction over a series in an opposing direction. Cross-hatching is often, but not exclusively, done with pen and ink.

Deep space refers to the illusion of space that is achieved on a two-dimensional plane through devices such as linear perspective, light and dark contrasts, and overlapping planes.

Dialogue is the give and take of argument and discussion of ideas among participants in a class critique or other forum.

Frame of reference is synonymous with the surface plane of a picture, but implies the relation of forms to the plane's perimeter.

Gesture means what a model or object is doing—hence, the action one perceives through empathy.

Graphite is the mineral ("lead" is a misnomer) used in pencils. Graphite is sold in bar and stick form.

Hatching is a method of creating values by drawing a series of parallel lines; usually associated with pen and ink.

Horizon line, in linear perspective, is synonymous with the "eye level line." The horizon line is the line on which receding parallels appear to converge.

Hot-press papers are papers prepared so that the surface remains smooth. Hot-press papers are often used for drawings in which details are important.

Intuition is the quality of understanding through empathic response rather than through conscious knowledge.

Isometric drawing is a method of drawing objects in space, often as diagrams, so that the objects' dimensions are shown in actual proportions as opposed to the foreshortening and converging parallels of linear perspective.

Mass, in the context of this book, refers to three-dimensional shape.

Metalpoint is an approach to drawing that is done on prepared surfaces with sharpened points of silver, gold, or other metals.

In **moving pose**, the model moves through a series of poses, like exercising, while the student concentrates on drawing the movement.

Negative shapes are the shapes around an object or between objects.

Nudity, as contrasted with "nakedness," implies an idealized depiction of the human form in which sensual responses are replaced by aesthetic concerns.

Outsider art is a contemporary name for folk art, or the art of self-taught artists. The accuracy of the word "outsider" would depend on one's conception of who or what is "inside" in art.

Pastels are prefabricated colored chalks that are formed by combining dry pigments with one of many possible binders, creating sticks of drawing materials.

Pattern, in this book, means the distribution of areas of value across the surface plane.

Picture plane means the two-dimensional plane of a page, canvas, etc. on which one's idea is created. Reference to the picture plane usually implies the importance of the retention of the quality of two dimensionality with which one starts.

Picture story is another way of saying comic strip, picture book, or any other form of story told through sequential pictures, usually in combination with words.

Plate finish is the smoothest of paper finishes. A plate finish is appropriate for highly detailed work where even a slightly rough texture would distract.

Play in this book means an approach to renewal or discovery through an unstructured, irresponsible attitude toward making art. To play is to let things happen.

Psychical distance is, in the arts, the distancing of oneself from an artwork so that its aesthetic quality can be perceived. Examples of aids to psychical distance are picture frames, sculpture pedestals, the theater stage, and the model stand.

Retablo is a popular form of Latin American picture story in which the artist describes a loved one's illness or injury and its outcome. Appropriate religious thanks are often included in the retablo.

Rhythm is a repetition of shapes, movements, colors, and so on as a means to unify a design.

A **scratchboard** is made by scratching through a blackened surface so that the lights in a drawing are created by the scratching tool.

Value, in visual works, means light and dark.

A **vanishing point** is a point in linear perspective where parallel lines appear to converge.

Verb, in drawing as in grammar, refers to action or state of being. In this book, *verb* refers to the gesture of a model or object—in other words, what the model or object is doing.

Vertical perspective is a means of picturing space that places faraway objects above middle-ground objects and middle-ground objects above objects in the foreground.

Index

PHOTO CREDITS

Figure 1.2: photo by James Flannery; Figure 1.4: photo by Roger Winter; Figure 1.5: photo by Michael Cavanaugh and Keith Montague; Figure 1.7: courtesy of Ms. Lee Krasner Pollack, from *Jackson Pollack: Works on Paper,* by Bernice Rose (New York: Museum of Modern Art, 1969); Figure 1.10: photo courtesy of the Whitney Museum of American Art, New York; Figure 1.11: reprinted with permission from *Notes in Hand* by Claes Oldenburg (London: Petersburg Press Ltd., 1968); Figure 1.12: reprinted with permission from *The Interaction of Color* by Josef Albers (New Haven, Conn.: Yale University Press, 1963); Figure 1.13: photo by Claude Duthuit.

Figure 2.1: reprinted with permission from *Chinese Painting and Calligraphy* by Wan-go Weng (New York: Dover Publications, 1978); Figures 2.3, 2.11: photos by Jean Mitchel; Figures 2.4, 2.5, 2.15: photos by Roger Winter; Figure 2.7: reprinted with permission from *The Drawings of Poussin* by Anthony Blunt (New Haven, Conn.: Yale University Press); Figure 2.10: photo by Roger Winter.

Figure 3.3: photo courtesy Art Resource; Figure 3.14: reprinted with permission from *Landscapes of Man* by Geoffrey and Susan Jellicoe (London: Thames and Hudson Ltd., 1975); Figure 3.15: reprinted with permission from *Despite Straight Lines* by Francois Bucher (Cambridge, Mass.: MIT Press, 1958); Figure 3.17: photo by Lynn Martin; Figures 3.18, 3.19, 3.20, 3.21: photos by Jean Mitchel; Figure 3.23: photo by Roger Winter; Figure 3.24: photo by Diana Ault.

Figure 4.1: courtesy of Mrs. Simon Guggenheim Fund, New York; Figure 4.4: bequest of Josephine N. Hopper; Figure 4.5: photo by Roger Winter; Figure 4.6: photo by Jean Mitchel.

Figure 5.1: photo by Robert Capa/ Magnum; Figure 5.2: photo by Cova-Jakori; Figure 5.3: photo by Roger Winter; Figure 5.4: photo by Larry Scholder; Figure 5.5: photo by Jean Mitchel; Figure 5.8: photo courtesy New York Graphic Society, Ltd., Greenwich; Figure 5.12: photo by Lynn Martin; Figure 5.15: photo by Jean Mitchel; Figure 5.16: reprinted with permission from *The Drawing of Seurat* by Gustave Kahn (New York: Dover Publications, 1971); Figure 5.18: photo by Roger Winter; Figures 5.20, 5.21, 5.22: photos by Lynn Martin.

Figure 6.6: photo courtesy City Art Museum of St. Louis, Missouri; Figure 6.11: photo courtesy Curator of the Royal Library; Figure 6.19: photo © 1997 The Art Institute of Chicago, all rights reserved; Figure 6.30: photo by Bill Kennedy.

Figure 7.1: photo by Lee Clockman; Figure 7.3: gift of the estate of Curt Valentin; Figure 7.8: photo courtesy of the Whitney Museum of American Art, New York; Figure 7.12: copyright © 1982 by the Estate of Max Ernst, courtesy SPADEM, Paris/VAGA, New York; Figure 7.13: photo by Attilio Bacci, Milan; Figure 7.14: courtesy Harry N. Abrams, Inc., New York; Figure 7.16: reprinted with permission from *Claes Oldenburg: Drawings and Prints* by Gene Baro (New York: Chelsea House, 1979).

Figure 8.1: from *Henry Moore's Sheep Sketchbook* by Henry Moore and Kenneth Clark (London: Thames and Hudson Ltd., 1980); Figure 8.5: photo courtesy University of Saint Thomas Art Department, Houston; Figure 8.6: photo courtesy the Museum of Modern Art, New York; Figure 8.7: photo courtesy the Museum of Fine Arts, Boston; Figure 8.8: photo copyright © 1982 SPADEM, Paris/VAGA, New York.

Quote from John Russell, p. 123: copyright © 1996 by The New York Times Co. Reprinted by permission.

ABOUT THE AUTHOR

Roger Winter taught painting and drawing at Southern Methodist University from 1963 to 1989. His past students include nationally recognized artists John Alexander, David Bates, Stephen Mueller, and Robert Yarber. Winter has received an NEA grant for painting and has been a guest critic at Washington University, the University of Pennsylvania, Brooklyn College, and Vermont Studio Center, among other schools. His work has been represented by the Fishbach Gallery in New York City and has been shown at galleries throughout the United States as well as being contained in many notable collections.